COLOUR
mixing
INDEX

JULIE COLLINS

COLOUR mixing INDEX

JULIE COLLINS

D&C
David and Charles

A DAVID & CHARLES BOOK
Copyright © David & Charles Limited 2007

David & Charles is an F+W Publications Inc.
company
4700 East Galbraith Road
Cincinnati, OH 45236

First published in the UK in 2007

A catalogue record for this book is available
from the British Library.

ISBN-13: 978-0-7153-2295-6 flexi
ISBN-10: 0-7153-2295-8 flexi
Printed in Singapore by KHL Printing Co Pte
Ltd.
for David & Charles
Brunel House Newton Abbot Devon

Commissioning Editor Freya Dangerfield
Assistant Editor Emily Rae
Art Editor Sarah Underhill
Designer Emma Sandquest
Production Controller Beverley Richardson

Visit our website at www.davidandcharles.
co.uk

David & Charles books are available from
all good bookshops; alternatively you can
contact our Orderline on 0870 9908222
or write to us at FREEPOST EX2 110, D&C
Direct, Newton Abbot, TQ12 4ZZ (no
stamp required UK only); US customers call
800-289-0963 and Canadian customers call
800-840-5220.

PUBLISHERS NOTE:
The publisher would like to thank
Winsor & Newton™ for their
generous contribution of the
materials for the colour mixes
throughout this book.

PAINT NAMES:
The names and colours of *Winsor
& Newton* paints are consistent
across all mediums. For example,
Naples yellow 422 is available as
oil paint, watercolour paint, an
acrylic and a gouache. However,
because different mediums are
manufactured in different ways, the
colour will not be exactly the same
across all mediums; the Naples
yellow watercolour may look
slightly different from the Naples
yellow acrylic.

COLOUR REPRODUCTION:
The images in this book have been
printed to the highest possible
standards of colour reproduction.
However, due to the printing
process, the author and publishers
cannot guarantee the exact
accuracy of the colour images in
this book.

Winsor & Newton have a policy of
continuous product developement
and improvement. Whilst the
information in this book is as
accurate as possible at the time of
printing, *Winsor & Newton* reserve
the right to amend specifications and
discontinue lines without notice. If
you have any queries please contact
the manufacturer (see page 318).

CONTENTS

Introduction

This book is a practical and inspirational manual that shows you a huge range of colour mixes in five popular mediums: watercolour, oil, acrylic, gouache and ink. The aim of the book is to encourage you to get to know colours well and be motivated to explore and experiment with colour. Use the book as a handy reference when you want to know how to mix a specific colour, or as a catalogue of inspiration when seeking ideas to try in your work.

At the end of the book (page 320) there is a colour viewing card. Cut this out and use it to view each colour swatch in isolation. This will help sharpen your perception of the colour, or allow you to pinpoint a specific shade to use in your own work.

HOW TO USE THIS BOOK

This book has five sections: one for each of the key media watercolour, oil, acrylic, gouache and ink. The colour mixes in each section follow a basic order: yellow, red, blue and green (some also include browns, blacks and greys). You can identify quickly the colour section you are in by the coloured strip down the edge of each left-hand page, which is an approximate match to the mixes on that spread. On each spread (see opposite), colour mixes are made using two colours: a base colour shown in a square on the left-hand page (A), and a mixing colour shown in a square at the top of the page (B). From these two colours, four mixes are made, using the colours in four different ratios (C).

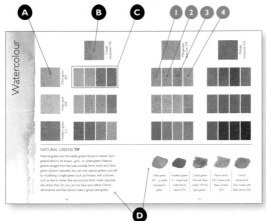

Mixes

In mix 1, colour B is added to colour A at a ratio of 1:4 (25% of colour B). Mixes 2, 3 and 4 have increasingly higher ratios of colour B (see left).

A The base colour used for the mixes

B The colour added to the base colour

C Four mixes (see below)

D Colour tips with additional information

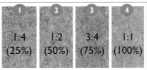

1	2	3	4
1:4 (25%)	1:2 (50%)	3:4 (75%)	1:1 (100%)

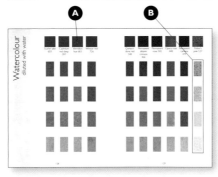

Dilutions

At the end of each section there are a few pages on diluting a colour, with water or with white paint, depending on the medium. This allows you to explore the tonal range that it is possible to obtain within an individual colour.

A The base colour used for the dilutions

B Four dilutions, from strong to weak

ABOUT COLOUR AND COLOUR MIXING

It is useful to know something about colour theory before you start experimenting with colour mixing. Traditionally, the relationships between colour have been demonstrated on a colour wheel. This is based on the relationships between primary, secondary and tertiary colours. The primary colours are red, yellow and blue. These cannot be made by mixing other colours, but all other colours can be created by mixing the primary colours in different proportions.

Mixing the **primary colours** together in equal proportions produces the **secondary colours**, as shown in the colour triangle below: orange (from red and yellow); violet (from red and blue); and green (from blue and yellow).

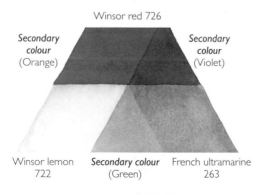

Winsor red 726

Secondary colour (Orange)

Secondary colour (Violet)

Winsor lemon 722

Secondary colour (Green)

French ultramarine 263

The colour triangle is made up of primary and secondary colours

The **tertiary colours** are created by mixing a primary colour with an adjacent secondary colour. The tertiary colours are: orange-yellow, red-orange, red-purple, purple-blue, blue-green and yellow-green.

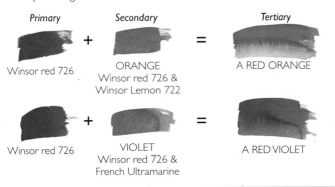

Primary	Secondary	Tertiary
Winsor red 726	ORANGE Winsor red 726 & Winsor Lemon 722	A RED ORANGE
Winsor red 726	VIOLET Winsor red 726 & French Ultramarine	A RED VIOLET

Making your own colour wheel, starting with just three tubes of paint for each of the primary colours, is an extremely useful exercise. You will be able to see what a huge array of colour mixes you can produce from blending your colours in different proportions. Here are a few ideas for some three-paint combinations from which you can explore a whole spectrum of colour mixes:

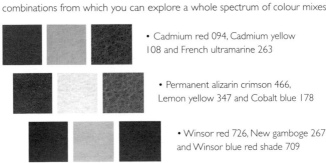

- Cadmium red 094, Cadmium yellow 108 and French ultramarine 263

- Permanent alizarin crimson 466, Lemon yellow 347 and Cobalt blue 178

- Winsor red 726, New gamboge 267 and Winsor blue red shade 709

WARM AND COOL COLOURS

When you are learning about colour mixing, a basic set of primary colours – red, blue and yellow – is a good starting point. Using just three colours as the base for all your colour mixes is very useful for understanding how colours work, both separately and when mixed. With such a small range, you get to know the paints and the colour mixes they create very intimately.

Another aspect of colour mixing that you can go on to explore is that of warm and cool colours. In your painting, you will notice that warm colours tend to stand out and therefore come to the forefront of a picture, whereas cool colours tend to recede and look as if they are in the distance or background. By using warm and cool colours cleverly you can create a feeling of space in your pictures.

We tend to think in broad categories, describing all reds as warm and all blues as cool, for example. Exploring with colour mixes will help you develop a more sophisticated appreciation for colour: you will see that some reds are in fact cool and some blues are warm.

The chart opposite explores the idea of warm and cool reds and blues in more detail. You will see, for example, that Permanent alizarin crimson 466 is a cool red, as it is slightly blue, whereas Scarlet lake 603 is a hot red, as it is fairly orange. French ultramarine 263 is a warm blue, whereas Cerulean blue 137 is a cool blue. This kind of knowledge – which can become instinctive after a while – is best learned through experimenting for yourself, using the mixes in this book as guidance.

WARM RED	**COOL RED**	**WARM BLUE**	**COOL BLUE**
Cadmium red 094	Winsor red 726	Winsor blue red shade 709	Winsor blue green shade 707
Quinacridone red 548	Opera rose 448	French ultramarine 263	Cerulean blue 137
Scarlet lake 603	Permanent rose 502	Cerulean blue red shade 140	Indanthrene blue 321
Cadmium scarlet 106	Permanent alizarin crimson 466	Cobalt blue 178	Phthalo turquoise 526

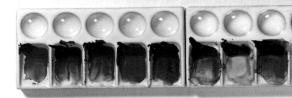

BLACKS AND GREYS

We know that there are many shades of red, orange and purple, and so on, but we often mistakenly tend to think of black as being a single colour with no variations. However, once you start to experiment with colour mixing, you will discover very soon that there are many shades of black, for example: blue-black, red-black, brownish-black, coal black, dull black, intense black, jet black and so on.

WATERCOLOUR GREYS FROM A BLUE AND A BROWN

These mixes illustrate that from one blue and one brown you can make at least eight different greys by altering the proportions of Cobalt blue 178 and Burnt umber 076 and also by adding more or less water to the mixes.

²/₃ blue to ¹/₃ brown – midtone

²/₃ brown to ¹/₃ blue – midtone

²/₃ blue to ¹/₃ brown in a very watery mix – pale blue

²/₃ brown to 1/3 blue in a very watery mix – pale brown

²/₃ blue to ¹/₃ brown – very strong/ dark mix

²/₃ brown to ¹/₃ blue – very strong/dark mix

²/₃ blue to ¹/₃ brown – pale mix

²/₃ brown and ¹/₃ blue – pale mix

Black is an overpowering colour that requires treating with respect. A strong black can kill off a delicate watercolour painting, whereas Mars black in a bold oil painting could make the painting work, as in some of Jackson Pollock's paintings. All the 'pure' blacks and greys available are featured in the colour charts in the book. However, you can also make your own blacks and greys. Here are a few ideas to explore.

WATERCOLOUR GREYS FROM MIXING YELLOW, RED AND BLUE

These mixes illustrate the fact that you don't actually need blacks or greys in your paintbox: mixing together any red, yellow and blue will make a black or grey. Here we have shown the different greys possible with different proportions of the three base colours. Experimenting more with your palette would give further interesting results to add to the ones shown here.

Yellow ochre
744

Permanent alizarin
crimson 466

Cobalt blue
178

½ yellow, ¼ blue
and ¼ red

½ red, ¼ yellow
and ¼ blue

½ blue, ¼ yellow
and red

RELATING TO COLOUR

Exploring colour theory, for example by creating your own colour wheel, is a great way to start experimenting with colour mixes. But learning about primary, secondary and tertiary colours can seem quite abstract and theoretical. Another approach is to explore colour and colour mixing in a more creative and intuitive way. Instead of simply thinking that an object is 'orange', think about what kind of orange it is – tangerine, peach, rusty or acid orange? Try relating to colour by associating it with a particular object. Instead of thinking 'green', think of moss green or apple green. Notice the colours around you, in nature or in manmade objects, and try to replicate them in your work.

COLOUR IN CONTEXT

Remember when you are exploring colour that colours are rarely seen in isolation but in context – next to one or more other colours. Our perception of colour is also strongly affected by both the light conditions and reflected colour. I once saw a wall in a shop painted a subtle yellow that I liked; I bought a sample pot of the paint to try at home, where it looked completely different from its appearance in the shop. Convinced I must have been given the wrong sample pot by mistake, I applied the paint to a large piece of paper and took it back to the shop to compare it. There was no mistake – my piece of paper was exactly the same as the wall at the shop – yet the light conditions and reflected colour made it look totally different at home.

Here is a chart of some of the watercolours I made with the colours in my paintbox recreating colours from the real world that inspired me

Eau de nil
(very watery Cobalt green 184 and Winsor lemon 722)

Apple blossom pink
(very watery Opera rose 448)

Steel grey
(Ivory black 331 and Indanthrene blue 321)

Night sky blue
(Indanthrene blue 321 and very little Ivory black 331)

Air Force blue
(Prussian blue 538 and Ivory black 331)

Rusty brown
(Indian red 317 and Burnt sienna 074)

Dirty paint water – red shade
(made from dirty paint water)

Dirty paint water – blue shade
(made from dirty paint water)

Acid yellow
(Lemon yellow 347 and little Cobalt green 184)

Acid green
(Cobalt green 184 with little Lemon yellow 347)

Tangerine
(Winsor orange red shade 723)

Claret
(Permanent alizarin crimson 466 and Perylene maroon 507)

Cherry red
(Permanent alizarin crimson 466 and Winsor red deep 725)

Brick red
(Perylene maroon 507 and New gamboge 267)

Seawater – summer
(Cerulean blue 137)

Seawater – winter
(Indanthrene blue 321 and little Burnt sienna 074)

15

COLOUR IN A PAINTING

The painting of the large parrot tulip opposite uses a limited palette but shows that by making some very subtle mixes you can achieve a very colourful painting. Also notice how each colour works with each other colour in the picture. The green compliments the bright red and the bright yellow green on the small leaf compliments the violet.

THE WATERCOLOURS USED WERE:

Winsor red 726

Winsor violet 733

New Gamboge 267

Cadmium orange 089

Winsor green yellow shade 721

1 Winsor red – mid tone

2 Winsor violet – dark mix

3 Winsor violet and Winsor red – 50% of each – mid tone

4 Winsor violet – mid tone

5 Cadmium orange and Winsor red – 50% of each – mid to strong tone

6 Cadmium orange with touch of Winsor red – mid tone

7 Winsor green yellow shade – mid tone

8 Winsor green yellow shade with touch of New Gamboge – mid tone

9 Shadow of Winsor violet – mid tone

10 Dark shadow of Winsor violet, Winsor green yellow shade and Winsor red – equal proportions

11 New Gamboge with touch of cadmium orange – mid tone

12 Winsor red with touch of cadmium orange – mid to dark tone

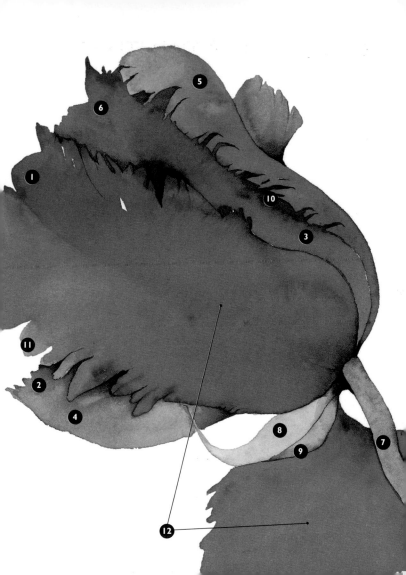

MATERIALS

All the materials used for this book are from *Winsor & Newton*. The paint
used here are all artists' quality and contain the highest concentratio
of pigments possible. Below are listed a range of the materials availab
from *Winsor & Newton* for each medium explored in this book. See als
the section opener for each medium for more information.

WATERCOLOUR
PAINTS
Artists' Water Colour or students'
Cotman ranges in tubes or pans.

BRUSHES
Sable brushes or synthetic brushes,
such as the Sceptre Gold II or
Cotman series.

PALETTES
Ceramic or plastic palettes, available
in various sizes and designs.

SUPPORTS
All acid-free watercolour papers are
suitable for use with watercolour.
These are available in various
weights, surfaces and sizes.

OIL

PAINTS
Artists' Oil Colour, students' Winton range, Oilbar oil sticks, Griffin Alkyd Fast Drying Oil Colour, and Artisan Water Mixable Oil Colour, all in tubes.

BRUSHES AND PALETTE KNIVES
Hog bristle brushes, synthetic alternatives and plastic or metal palette knives.

PALETTES
Mahogany, plywood, synthetic and tear-off palettes.

SUPPORTS
Primed canvas, oil painting boards, primed wooden panels, oil pads and sized paper.

MEDIUMS AND VARNISHES
Linseed oil, white spirit, turpentine and low-odour Sansodor. Gloss, matt, dammar and wax varnishes.

ACRYLIC

PAINTS

Finity Artists' Acrylic Colour and students' Galeria Flow Formula Acrylic Colour range in tubes or pots.

BRUSHES AND PAINTING KNIVES

Synthetic brushes, such as the Galeria or University range, or natural brushes made from hog bristle. Plastic or metal palette knives.

PALETTES

Acrylic palettes with absorbent reservoir paper, or tear-off palettes.

SUPPORTS

Canvas, acrylic boards, primed wood panels, acrylic pads and watercolour paper.

MEDIUMS AND TEXTURE GELS

Acrylic Flow Improver, Acrylic Retarder, Iridescent Medium, Matt Medium, Gloss Medium, Matt and Gloss Gel Mediums, Fine, Medium and Coarse Texture Gels.

GOUACHE

PAINTS
Designers' Gouache Colour in tubes
or pots.

BRUSHES
Sable brushes or synthetic brushes,
such as the Sceptre Gold II or
Cotman series.

PALETTES
Ceramic or plastic palettes, available
in various sizes and designs.

SUPPORTS
All acid-free watercolour papers are
suitable for use with gouache. These
are available in various weights,
surfaces and sizes. Designers' boards.

MEDIUMS
None.

INK

INKS
Drawing Inks.

BRUSHES AND PENS
Sable brushes or synthetic brushes,
such as the Sceptre Gold II or
Cotman series. Dipping pens.

PALETTES
Ceramic or plastic palettes, available
in various sizes and designs.

SUPPORTS
Cartridge paper. All acid-free
watercolour papers are suitable for
use with ink. These are available in
various weights, surfaces and sizes.

MEDIUMS
None, but can be watered down
with distilled water.

WATERCOLOUR

Water-based paints have a very long artistic tradition, and watercolours as we know them today became commercially available in the eighteenth century (before then, artists mixed their own pigments). Watercolour paints consist of a pigment mixed with a binder (usually gum arabic), and are available in tubes or in pans.

Watercolours tend to be associated with subtle, delicate shades of colour, with light-coloured washes that bleed together and blend on the page. However, watercolours can be anything but insipid, as the following pages will show – fresh, jewel-bright and vibrant colours mixes are also possible.

The intensity of a watercolour mix depends partly on the amount of water added to it. In addition, watercolours can be transparent, semi-transparent, semi-opaque or opaque. This information is indicated by

a symbol found on the label of each tube or individually wrapped pan. Transparent colours are more brilliant and refract more light; they allow you to create a pure glazing effect by laying several layers of paint over each other. Opaque colours tend to produce a flatter surface and can cover any colours beneath.

Watercolours can also have staining or granulating qualities (this information will be indicated on the label). Staining colours are more difficult to 'lift off' or change once applied – the nature of the pigment of such paints means that they penetrate more deeply into the paper. Granulating colours produce a mottled or grainy effect as they settle on the paper, which many artists find attractive as it gives visual texture to a painting. Non-granulating colours will produce a smooth, clear wash of colour.

Watercolours are used on special watercolour paper, which has a textured surface that absorbs the liquid paint. A variety of weights and surfaces are available.

Watercolour

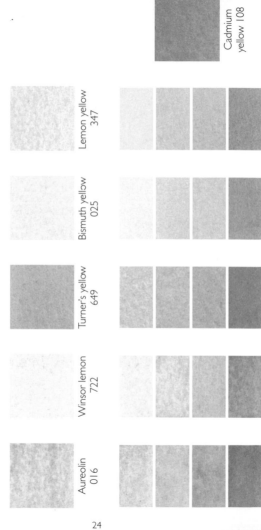

Cadmium yellow 108

Lemon yellow 347

Bismuth yellow 025

Turner's yellow 649

Winsor lemon 722

Aureolin 016

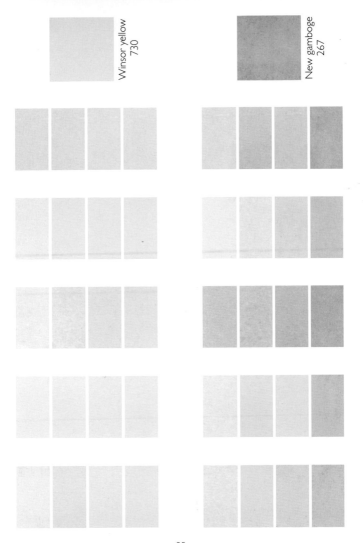

Winsor yellow
730

New gamboge
267

Watercolour

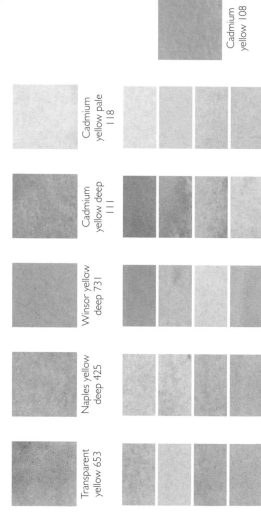

Cadmium yellow 108

Cadmium yellow pale 118

Cadmium yellow deep 111

Winsor yellow deep 731

Naples yellow deep 425

Transparent yellow 653

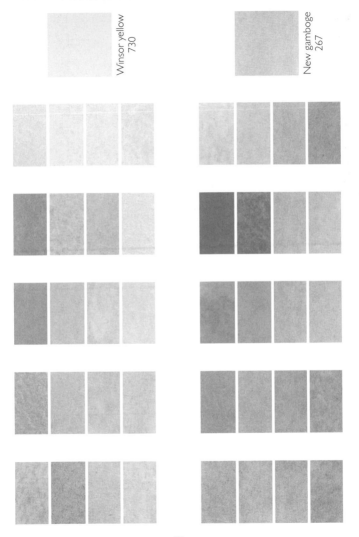

Winsor yellow
730

New gamboge
267

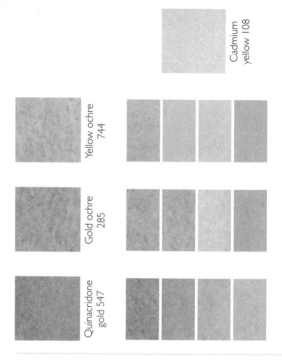

Watercolour

Cadmium yellow 108

Yellow ochre 744

Gold ochre 285

Quinacridone gold 547

BRIGHT YELLOWS **TIP**

If you require bright yellow, either use one pure yellow
from your palette, or mix it with one other yellow to get
the exact yellow that you need. Note how the Cadmium
yellows and Lemon yellow shown opposite are bright but
opaque, whereas Winsor yellow and Bismuth yellow are
bright yet semi-opaque. In addition, Lemon yellow is a
granulating colour while the others are staining colours.

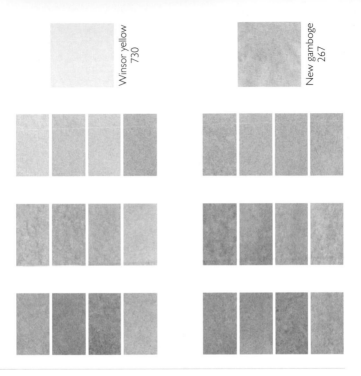

Winsor yellow
730

New gamboge
267

Winsor yellow
deep 731

Bismuth yellow
025

Cadmium
yellow deep
111

Cadmium
yellow pale 118

Lemon yellow
347

Watercolour

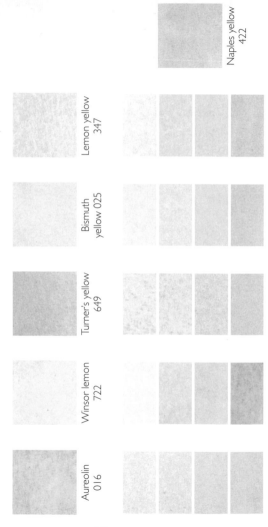

Naples yellow
422

Lemon yellow
347

Bismuth
yellow 025

Turner's yellow
649

Winsor lemon
722

Aureolin
016

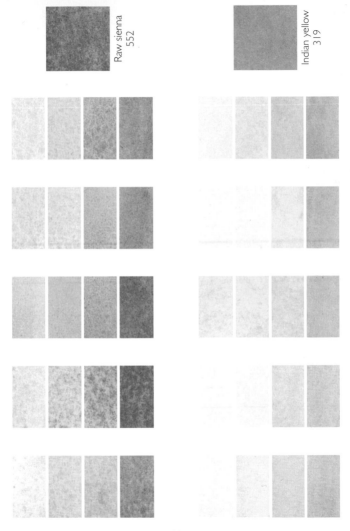

Raw sienna
552

Indian yellow
319

Watercolour

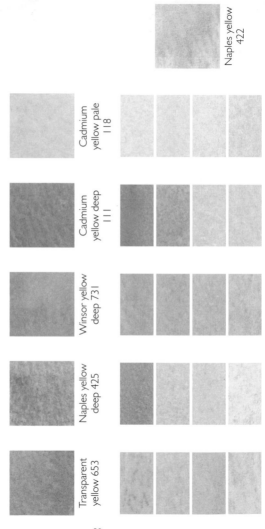

Naples yellow
422

Cadmium
yellow pale
118

Cadmium
yellow deep
111

Winsor yellow
deep 731

Naples yellow
deep 425

Transparent
yellow 653

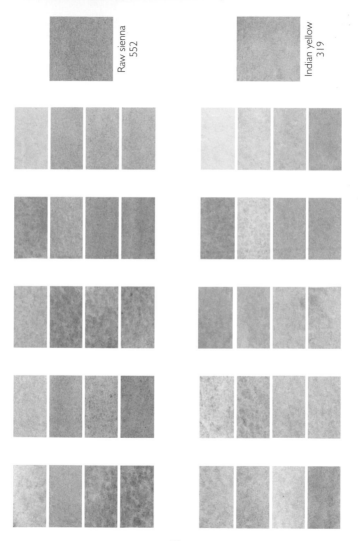

Raw sienna
552

Indian yellow
319

33

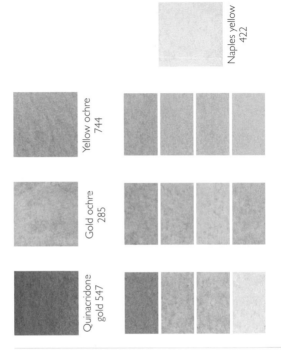

Watercolour

Naples yellow
422

Yellow ochre
744

Gold ochre
285

Quinacridone
gold 547

PALE YELLOWS **TIP**

Yellows in watercolour tend to look dirty very easily, and it
is imperative to keep these colours clean in your paintbox:
clean off any stray greens or blues, as even the tiniest
amount will taint your yellows.

Note the subtle differences between these pale yellows,
even when they are diluted with a lot of water, as in the
examples opposite. Turner's yellow is an opaque colour;
Gold ochre is semi-opaque; and the others are transparent.

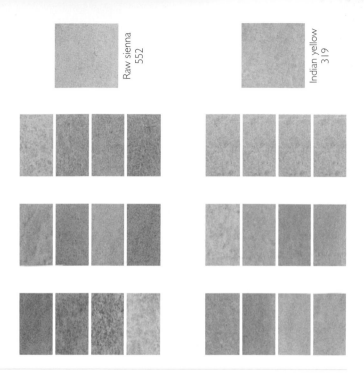

Raw sienna
552

Indian yellow
319

| Turner's yellow 649 | Transparent yellow 653 | Raw sienna 552 | Aureolin 016 | Gold ochre 285 |

Watercolour

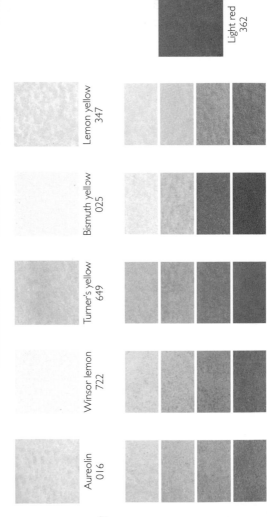

Light red
362

Lemon yellow
347

Bismuth yellow
025

Turner's yellow
649

Winsor lemon
722

Aureolin
016

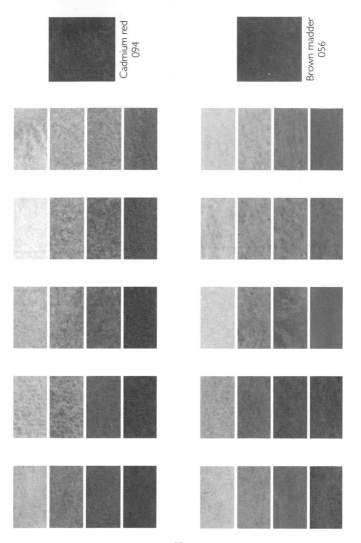

Cadmium red
094

Brown madder
056

Watercolour

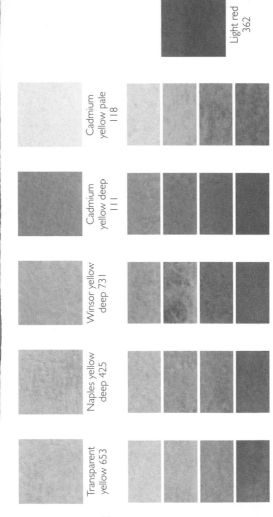

Light red
362

Cadmium
yellow pale
118

Cadmium
yellow deep
111

Winsor yellow
deep 731

Naples yellow
deep 425

Transparent
yellow 653

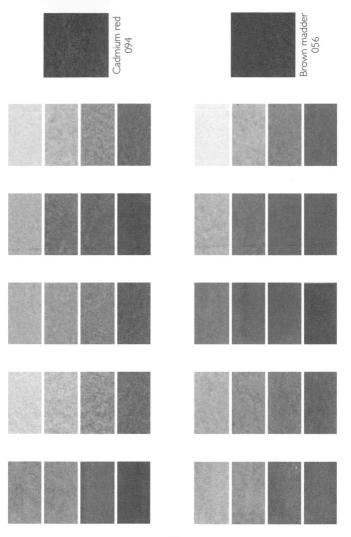

Cadmium red
094

Brown madder
056

39

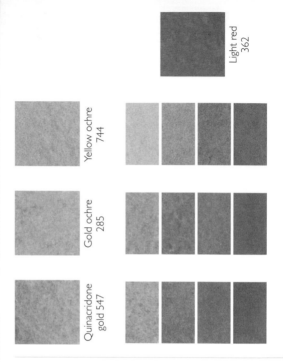

Light red
362

Yellow ochre
744

Gold ochre
285

Quinacridone
gold 547

EARTH YELLOWS **TIP**

When choosing your yellows, consider their opacity and transparency, as well as their colour; for example, Raw sienna is transparent, whereas Yellow ochre is semi-opaque and Gold ochre semi-transparent. See the difference when Raw sienna is mixed with Naples yellow, an opaque colour. Remember that your yellow will only look bright when painted on top of pure white paper – any colour underneath will affect your yellow.

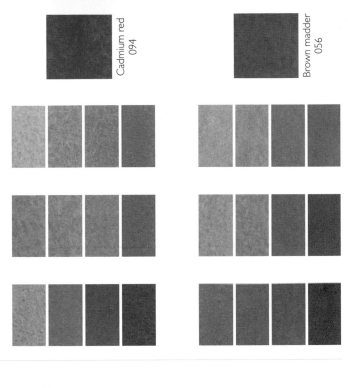

Cadmium red 094

Brown madder 056

Raw sienna 552

Yellow ochre 744

Gold ochre 285

Raw sienna 552 and
Naples yellow 422

Watercolour

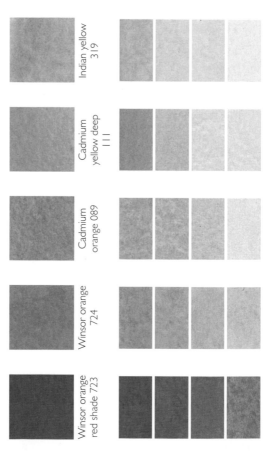

Cadmium lemon 086

Indian yellow 319

Cadmium yellow deep 111

Cadmium orange 089

Winsor orange 724

Winsor orange red shade 723

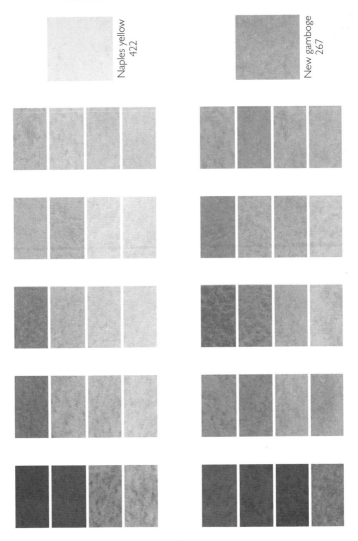

Naples yellow
422

New gamboge
267

Watercolour

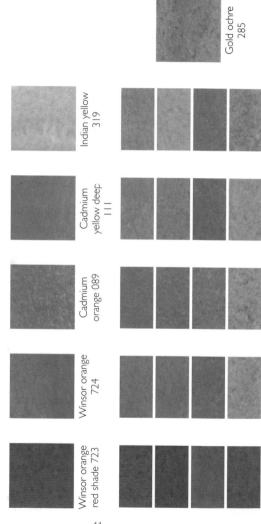

Gold ochre
285

Indian yellow
319

Cadmium
yellow deep
111

Cadmium
orange 089

Winsor orange
724

Winsor orange
red shade 723

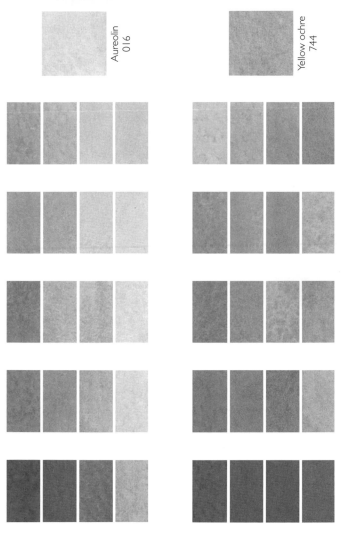

Aureolin
016

Yellow ochre
744

45

Watercolour

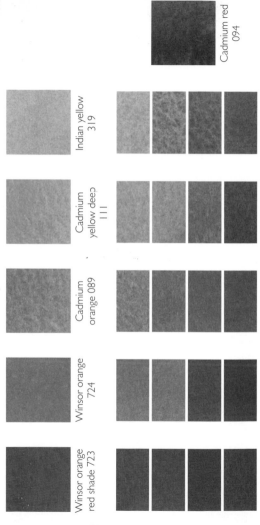

Cadmium red
094

Indian yellow
319

Cadmium
yellow deep
111

Cadmium
orange 089

Winsor orange
724

Winsor orange
red shade 723

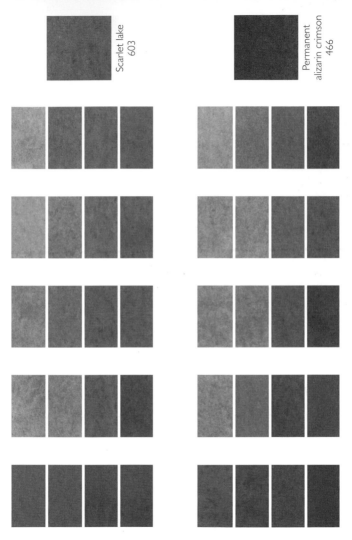

Scarlet lake
603

Permanent
alizarin crimson
466

Watercolour

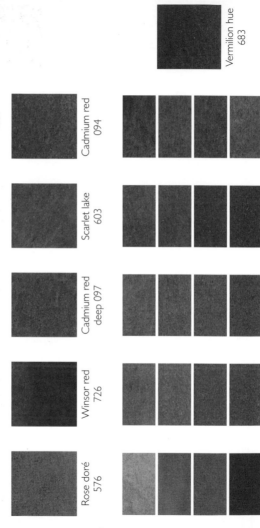

Vermilion hue
683

Cadmium red
094

Scarlet lake
603

Cadmium red
deep 097

Winsor red
726

Rose doré
576

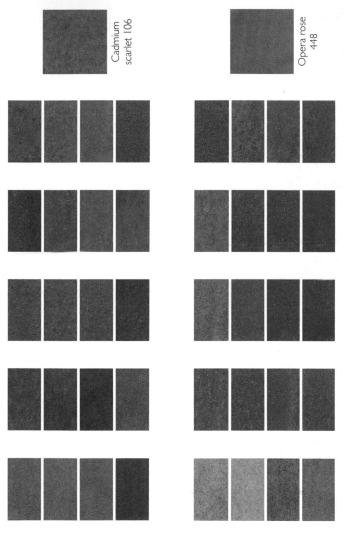

Cadmium
scarlet 106

Opera rose
448

Watercolour

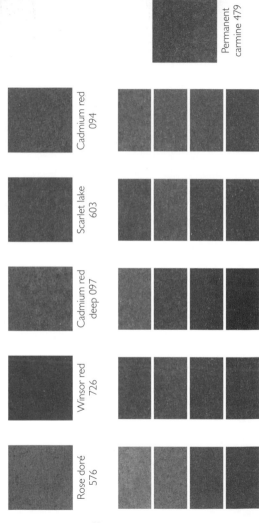

Permanent carmine 479

Cadmium red 094

Scarlet lake 603

Cadmium red deep 097

Winsor red 726

Rose doré 576

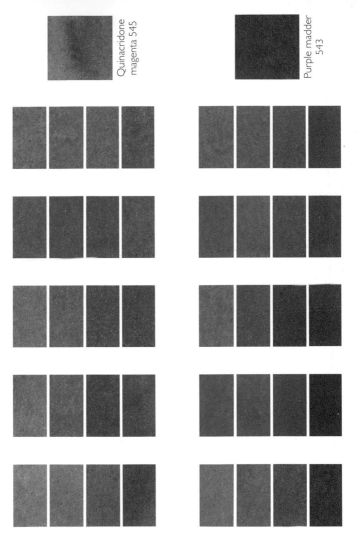

Quinacridone
magenta 545

Purple madder
543

Watercolour

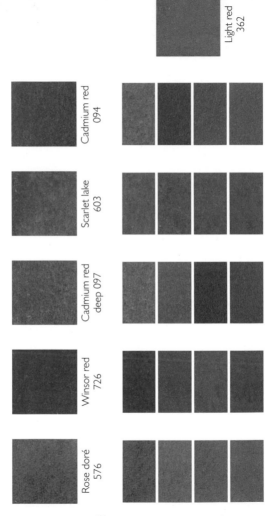

Light red
362

Cadmium red
094

Scarlet lake
603

Cadmium red
deep 097

Winsor red
726

Rose doré
576

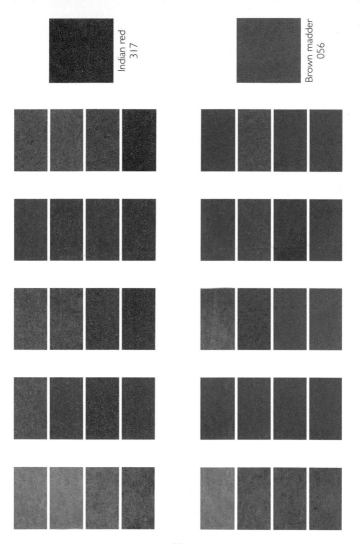

Indian red
317

Brown madder
056

Watercolour

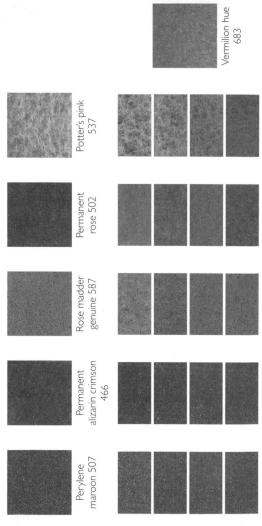

Vermilion hue
683

Potter's pink
537

Permanent
rose 502

Rose madder
genuine 587

Permanent
alizarin crimson
466

Perylene
maroon 507

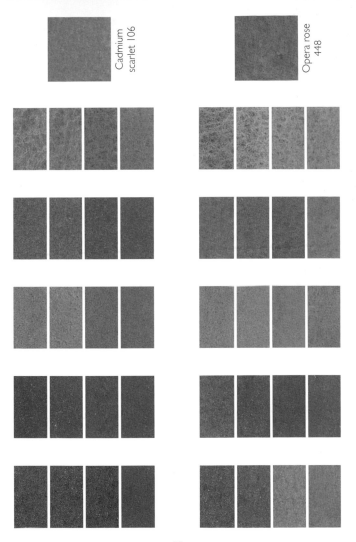

Cadmium scarlet 106

Opera rose 448

Watercolour

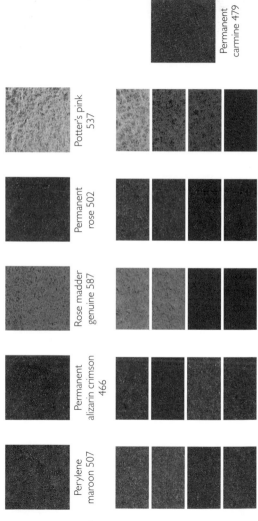

Permanent carmine 479

Potter's pink 537

Permanent rose 502

Rose madder genuine 587

Permanent alizarin crimson 466

Perylene maroon 507

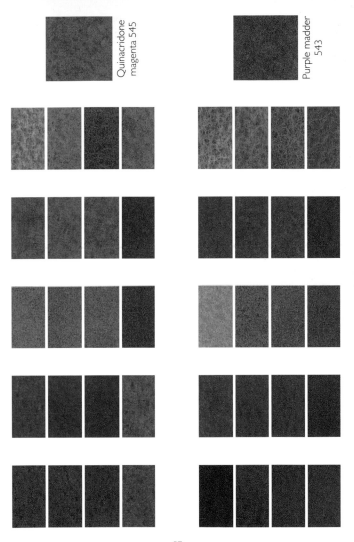

Quinacridone magenta 545

Purple madder 543

Watercolour

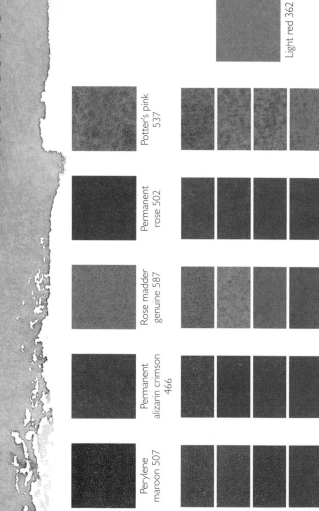

Light red 362

Potter's pink 537

Permanent rose 502

Rose madder genuine 587

Permanent alizarin crimson 466

Perylene maroon 507

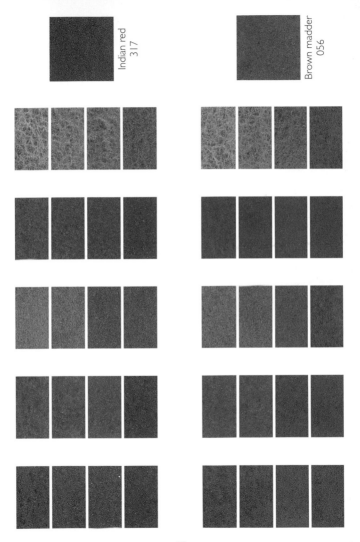

Indian red
317

Brown madder
056

59

Watercolour

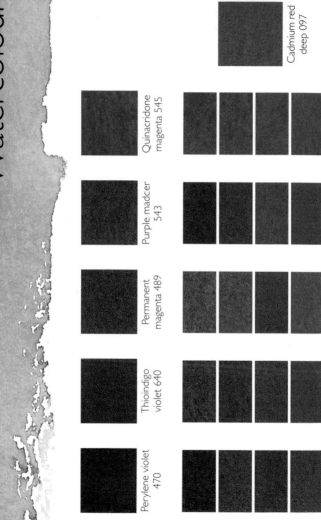

Cadmium red
deep 097

Quinacridone
magenta 545

Purple madcer
543

Permanent
magenta 489

Thioindigo
violet 640

Perylene violet
470

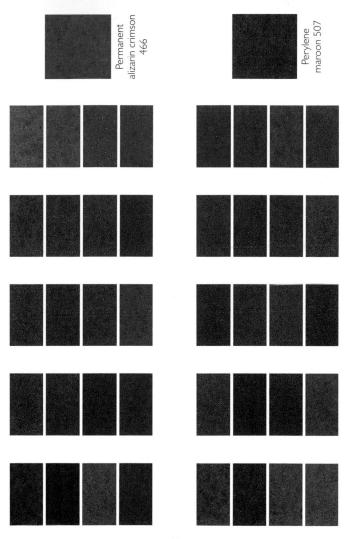

Permanent
alizarin crimson
466

Perylene
maroon 507

Watercolour

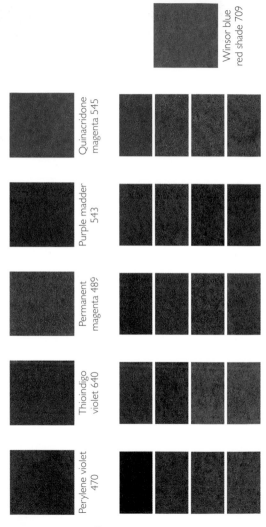

Winsor blue
red shade 709

Quinacridone
magenta 545

Purple madder
543

Permanent
magenta 489

Thioindigo
violet 640

Perylene violet
470

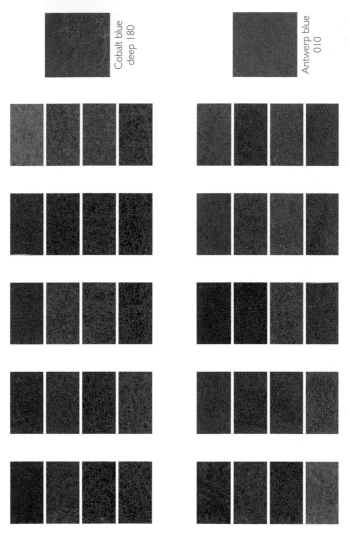

Cobalt blue
deep 180

Antwerp blue
010

Watercolour

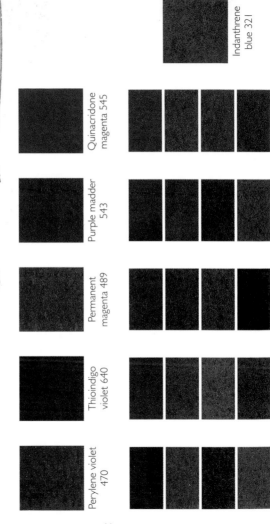

Indanthrene blue 321

Quinacridone magenta 545

Purple madder 543

Permanent magenta 489

Thioindigo violet 640

Perylene violet 470

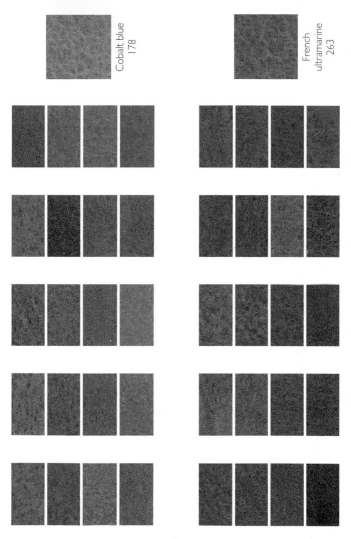

Cobalt blue
178

French
ultramarine
263

Watercolour

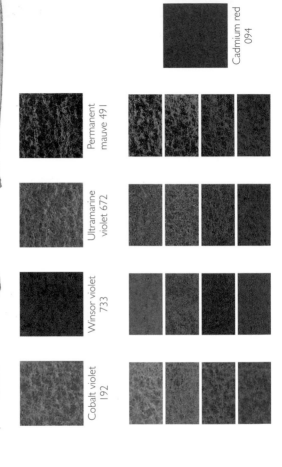

Cadmium red
094

Permanent
mauve 491

Ultramarine
violet 672

Winsor violet
733

Cobalt violet
192

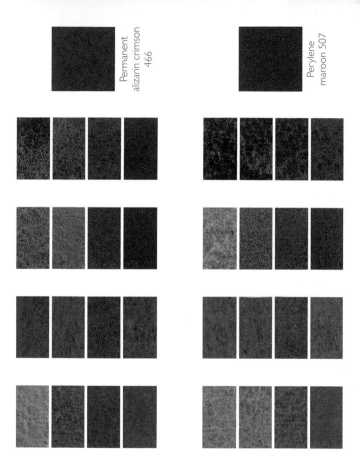

Permanent
alizarin crimson
466

Perylene
maroon 507

Watercolour

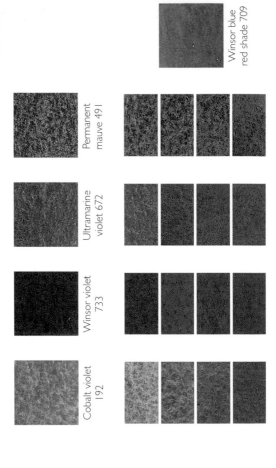

Winsor blue
red shade 709

Permanent
mauve 491

Ultramarine
violet 672

Winsor violet
733

Cobalt violet
192

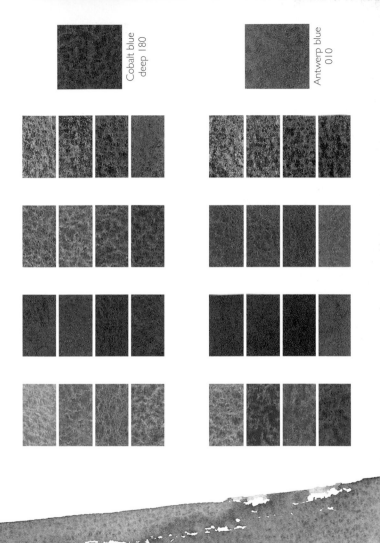

Cobalt blue
deep 180

Antwerp blue
010

Watercolour

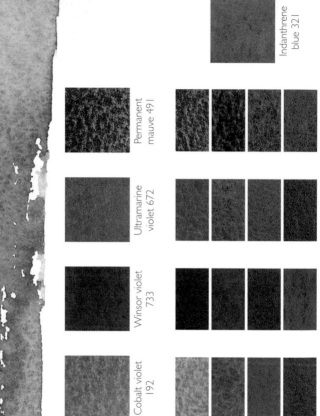

Indanthrene blue 321

Permanent mauve 491

Ultramarine violet 672

Winsor violet 733

Cobalt violet 192

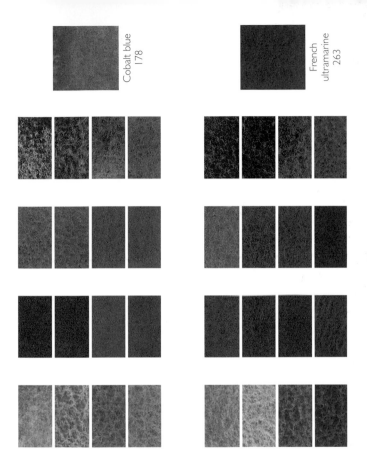

Cobalt blue
178

French
ultramarine
263

Watercolour

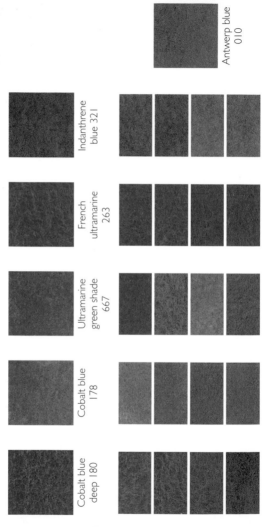

Antwerp blue
010

Indanthrene
blue 321

French
ultramarine
263

Ultramarine
green shade
667

Cobalt blue
178

Cobalt blue
deep 180

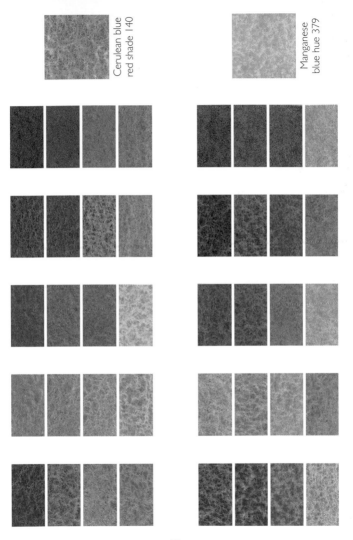

Cerulean blue
red shade 140

Manganese
blue hue 379

Watercolour

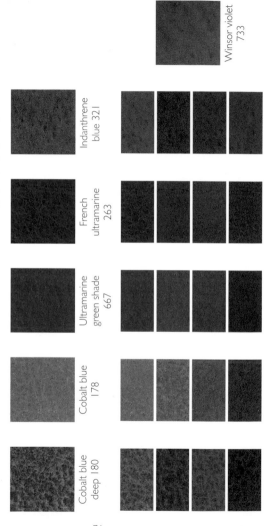

Winsor violet
733

Indanthrene
blue 321

French
ultramarine
263

Ultramarine
green shade
667

Cobalt blue
178

Cobalt blue
deep 180

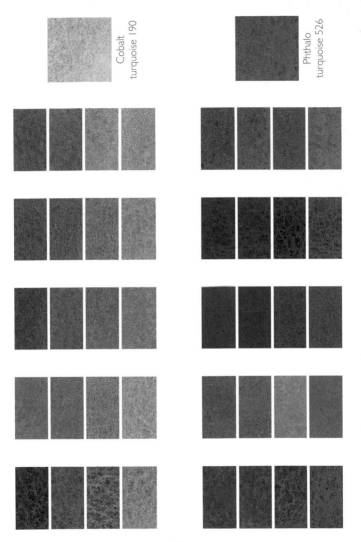

Cobalt
turquoise 190

Phthalo
turquoise 526

Watercolour

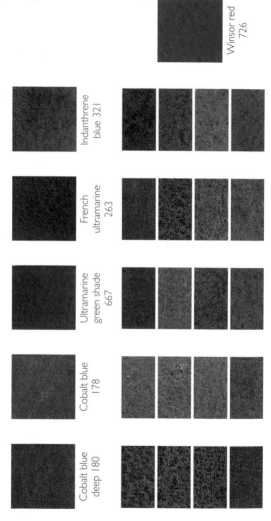

Winsor red
726

Indanthrene
blue 321

French
ultramarine
263

Ultramarine
green shade
667

Cobalt blue
178

Cobalt blue
deep 180

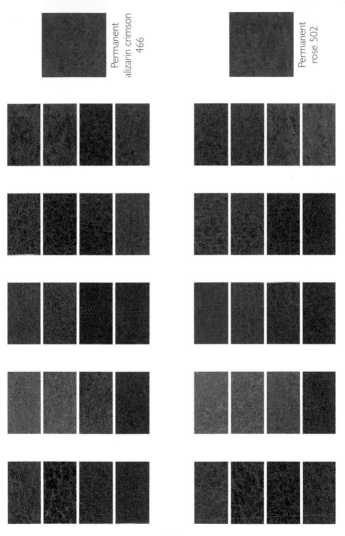

Permanent
alizarin crimson
466

Permanent
rose 502

Watercolour

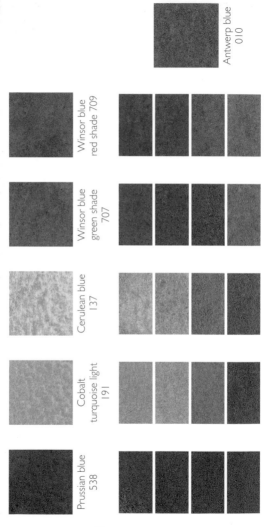

Antwerp blue
010

Winsor blue
red shade 709

Winsor blue
green shade
707

Cerulean blue
137

Cobalt
turquoise light
191

Prussian blue
538

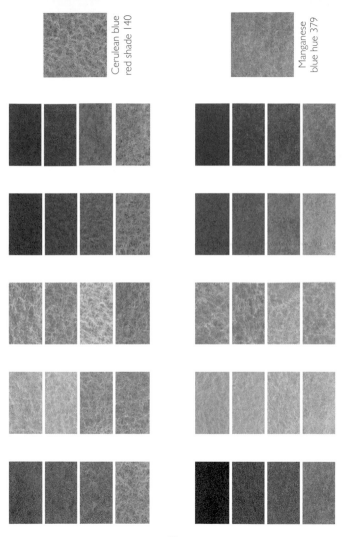

Cerulean blue
red shade 140

Manganese
blue hue 379

Watercolour

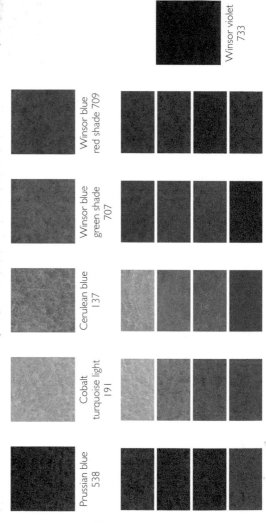

Winsor violet
733

Winsor blue
red shade 709

Winsor blue
green shade
707

Cerulean blue
137

Cobalt
turquoise light
191

Prussian blue
538

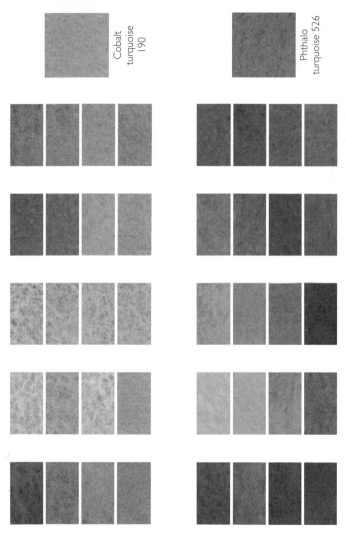

Cobalt turquoise 190

Phthalo turquoise 526

81

Watercolour

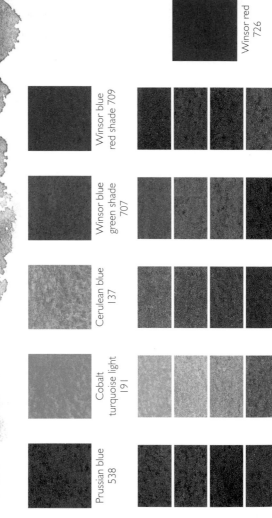

Winsor red 726

Winsor blue red shade 709

Winsor blue green shade 707

Cerulean blue 137

Cobalt turquoise light 191

Prussian blue 538

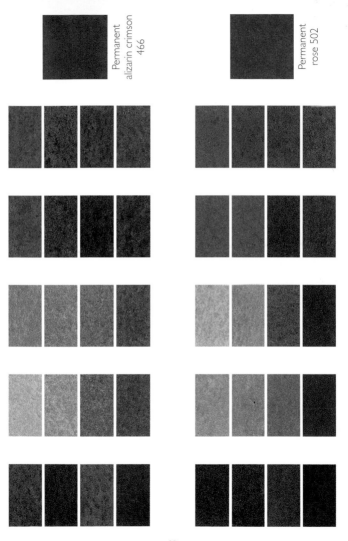

Permanent
alizarin crimson
466

Permanent
rose 502

83

Watercolour

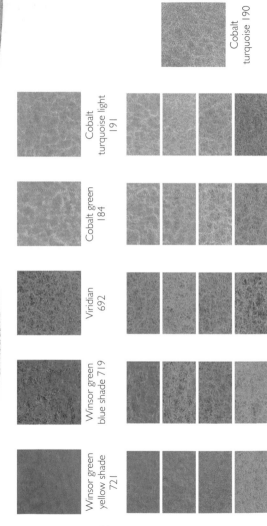

Cobalt turquoise 190

Cobalt turquoise light 191

Cobalt green 184

Viridian 692

Winsor green blue shade 719

Winsor green yellow shade 721

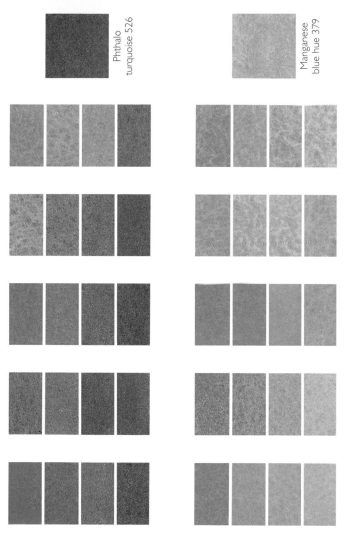

Phthalo turquoise 526

Manganese blue hue 379

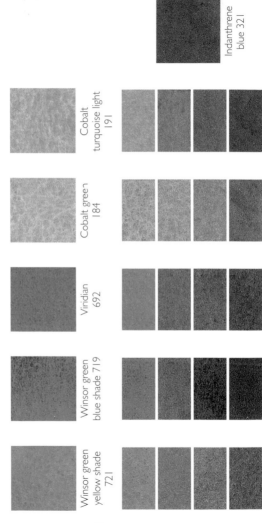

Watercolour

Indanthrene
blue 321

Cobalt
turquoise light
191

Cobalt green
184

Viridian
692

Winsor green
blue shade 719

Winsor green
yellow shade
721

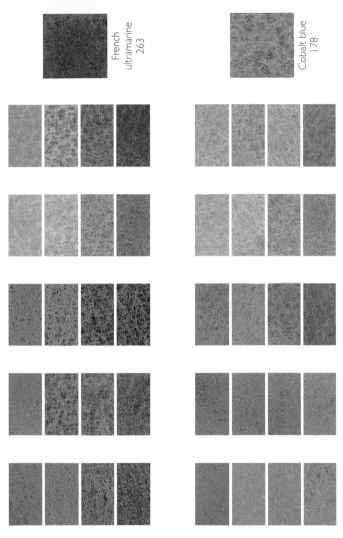

French
ultramarine
263

Cobalt blue
178

Watercolour

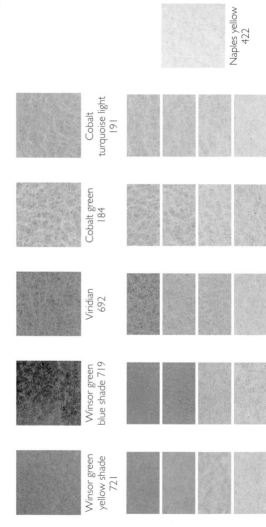

Naples yellow
422

Cobalt
turquoise light
191

Cobalt green
184

Viridian
692

Winsor green
blue shade 719

Winsor green
yellow shade
721

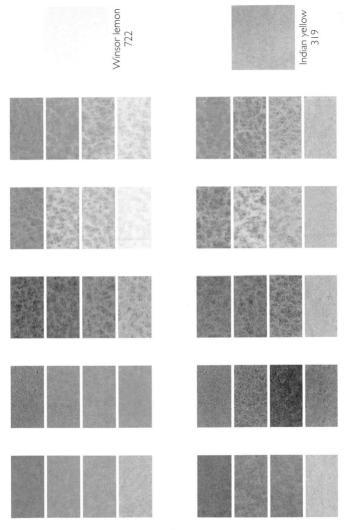

Winsor lemon
722

Indian yellow
319

Watercolour

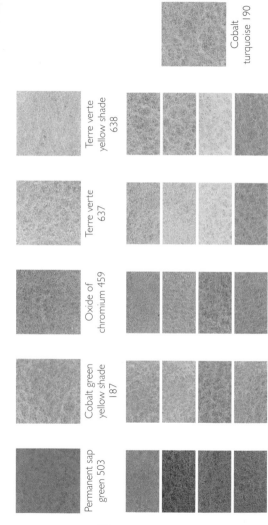

Cobalt turquoise 190

Terre verte yellow shade 638

Terre verte 637

Oxide of chromium 459

Cobalt green yellow shade 187

Permanent sap green 503

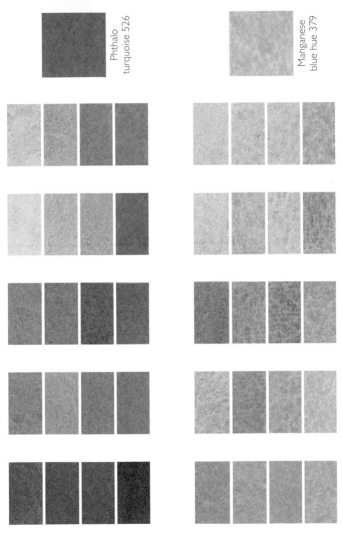

Phthalo
turquoise 526

Manganese
blue hue 379

91

Watercolour

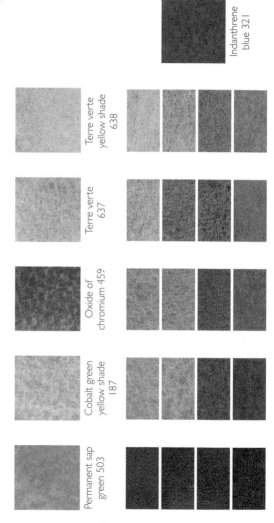

Indanthrene blue 321

Terre verte yellow shade 638

Terre verte 637

Oxide of chromium 459

Cobalt green yellow shade 187

Permanent sap green 503

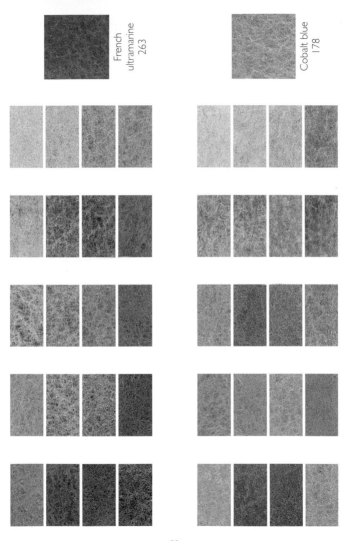

French
ultramarine
263

Cobalt blue
178

Watercolour

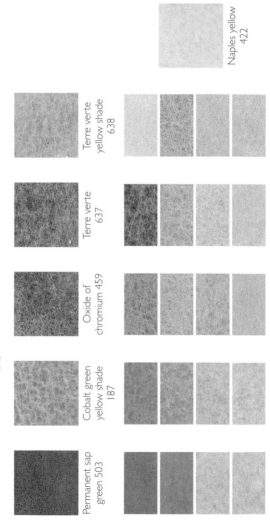

Naples yellow
422

Terre verte
yellow shade
638

Terre verte
637

Oxide of
chromium 459

Cobalt green
yellow shade
187

Permanent sap
green 503

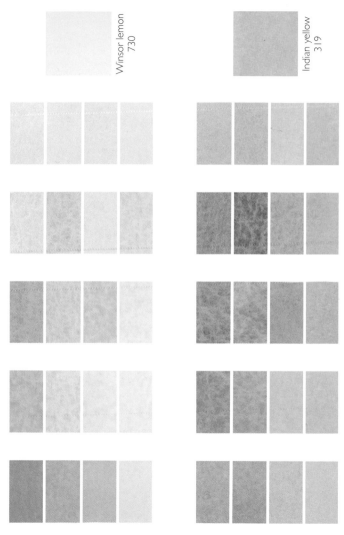

Winsor lemon
730

Indian yellow
319

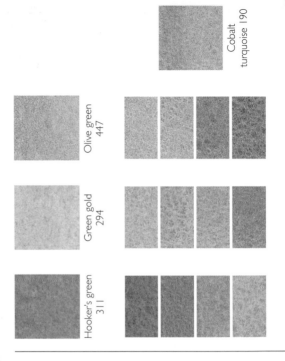

Cobalt turquoise 190

Olive green 447

Green gold 294

Hooker's green 311

NATURAL GREENS **TIP**

Natural greens are the subtle greens found in nature. Such greens tend to be brown-, grey- or violet-green. Natural greens straight from the tube include Terre verte and Olive green (shown opposite). You can mix natural greens yourself by modifying a bright green, such as Viridian, with a brown, such as Burnt umber (the second and third mixes opposite also show this). Or you can mix blue and yellow: French ultramarine and Raw sienna make a good olive-green.

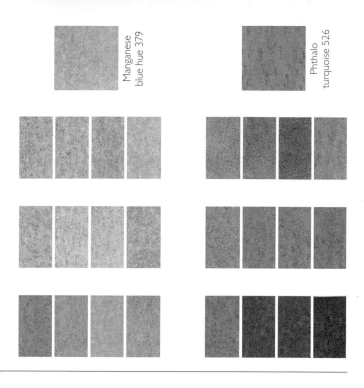

Manganese blue hue 379

Phthalo turquoise 526

Olive green 447 – a subtle transparent green

Hooker's green 311 mixed with a little Burnt sienna 074

Cobalt green 184 with Raw umber 554 for grey-green

Terre verte 637 mixed with Raw umber 554

French ultramarine 263 mixed with Raw sienna 552

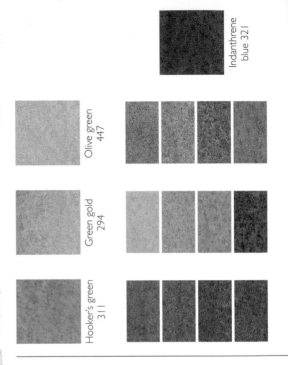

Watercolour

Indanthrene blue 321

Olive green 447

Green gold 294

Hooker's green 311

GREEN FROM BLUE AND YELLOW **TIP**

Try experimenting with all the yellows and blues in your watercolour box to see how many greens you can make. Antwerp blue with Indian yellow creates an emerald shade compared to the other mixes here, which are more olive- and grey-green. Certain blues and yellows produce a granulated effect, such as French ultramarine with Raw sienna. Note the different greens produced from mixing blues with Raw sienna and with Lemon yellow.

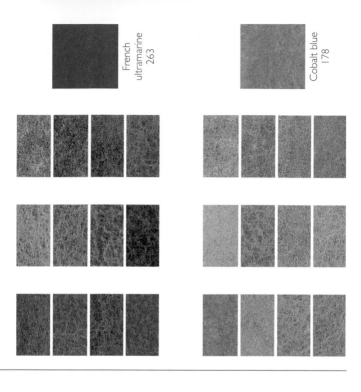

French ultramarine 263

Cobalt blue 178

| French ultramarine 263 with Raw sienna 552 | French ultramarine 263 with Lemon yellow 347 | Cobalt blue 178 with Raw sienna 552 | Cobalt blue 178 with Lemon yellow 347 | Antwerp blue 010 with Indian yellow 319 |

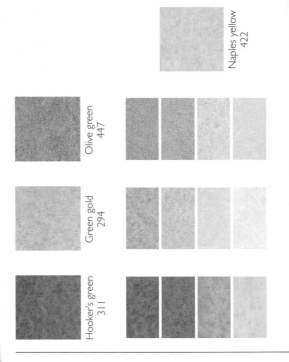

Naples yellow
422

Olive green
447

Green gold
294

Hooker's green
311

BRIGHT GREENS **TIP**

The bright greens shown opposite have very luminous
qualities; this can make them less suitable for painting from
nature unless they are modified by a brown such as Burnt
sienna. In their pure form, such colours may lend themselves
to use in more modern or imaginative styles of painting.

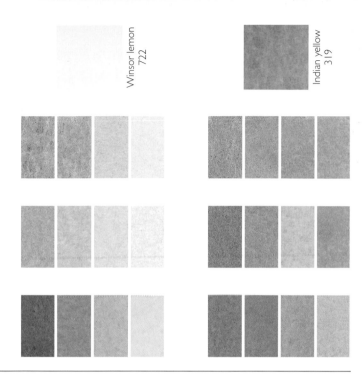

Winsor lemon
722

Indian yellow
319

Winsor green
blue shade 719

Winsor green
yellow shade
721

Cobalt green
yellow shade
187

Viridian
692

Cobalt green
184

Watercolour

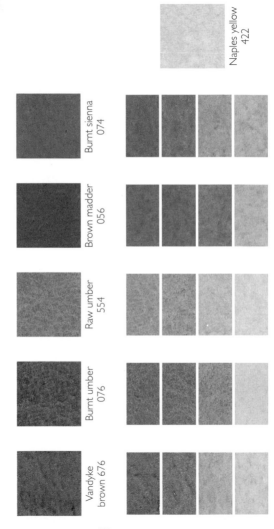

Naples yellow
422

Burnt sienna
074

Brown madder
056

Raw umber
554

Burnt umber
076

Vandyke
brown 676

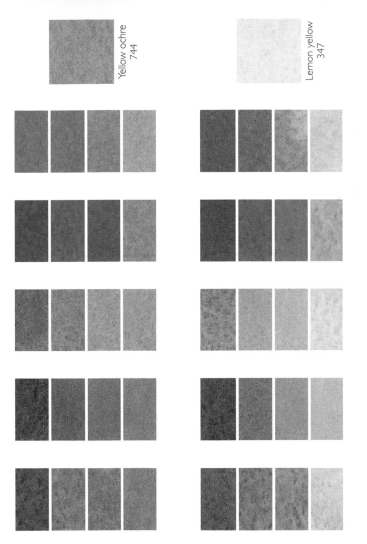

Yellow ochre
744

Lemon yellow
347

Watercolour

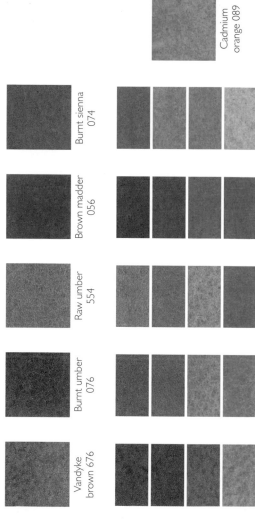

Cadmium orange 089

Burnt sienna 074

Brown madder 056

Raw umber 554

Burnt umber 076

Vandyke brown 676

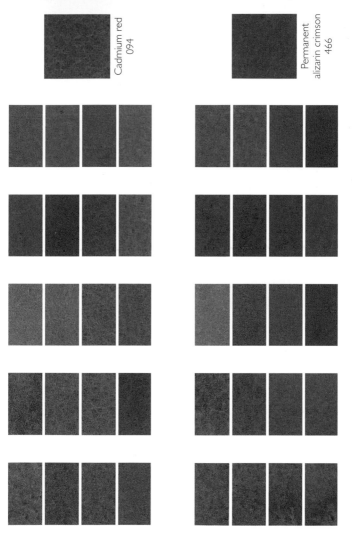

Cadmium red
094

Permanent
alizarin crimson
466

105

Watercolour

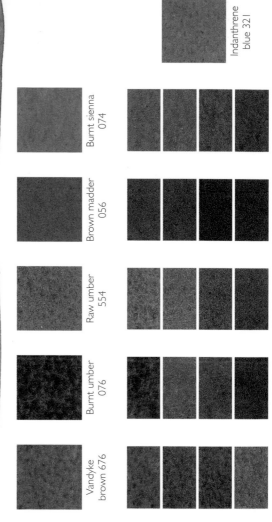

Indanthrene blue 321

Burnt sienna 074

Brown madder 056

Raw umber 554

Burnt umber 076

Vandyke brown 676

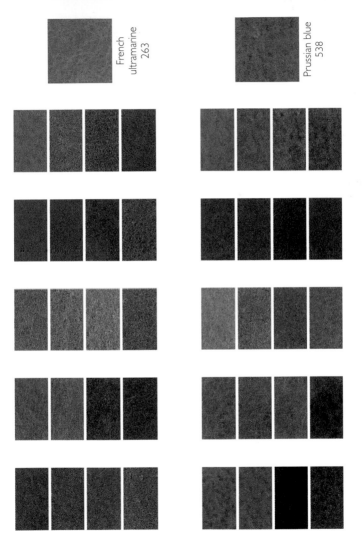

French
ultramarine
263

Prussian blue
538

Watercolour

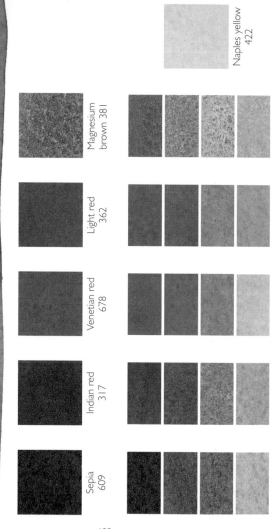

Naples yellow
422

Magnesium
brown 381

Light red
362

Venetian red
678

Indian red
317

Sepia
609

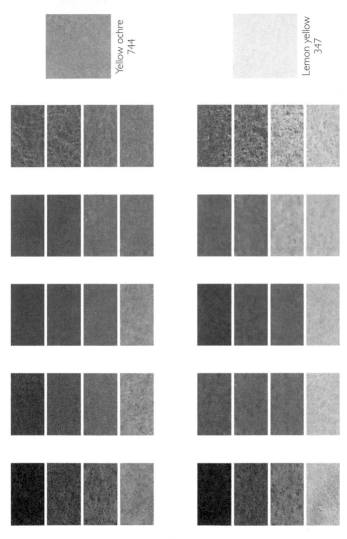

Yellow ochre
744

Lemon yellow
347

Watercolour

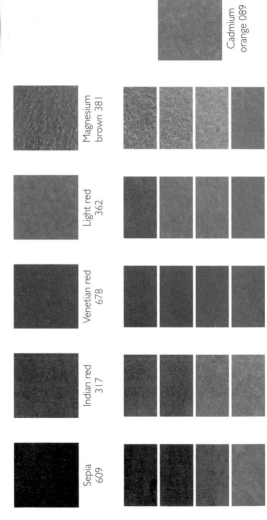

Cadmium orange 089

Magnesium brown 381

Light red 362

Venetian red 678

Indian red 317

Sepia 609

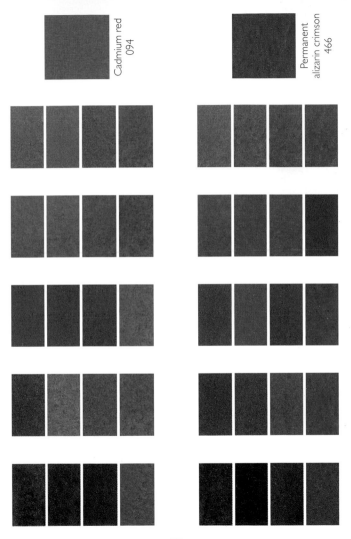

Cadmium red
094

Permanent
alizarin crimson
466

III

Watercolour

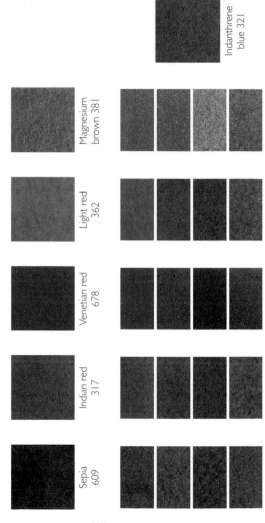

Indanthrene blue 321

Magnesium brown 381

Light red 362

Venetian red 678

Indian red 317

Sepia 609

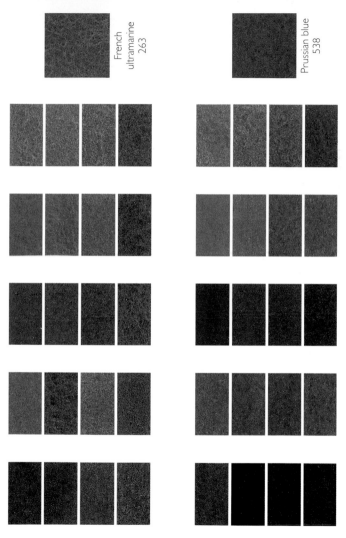

French ultramarine 263

Prussian blue 538

Watercolour

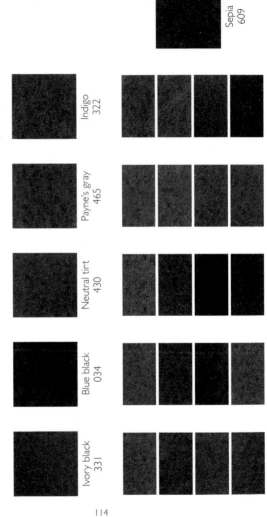

Sepia
609

Indigo
322

Payne's gray
465

Neutral tint
430

Blue black
034

Ivory black
331

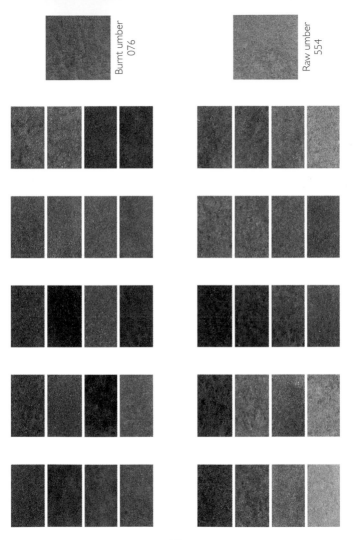

Burnt umber
076

Raw umber
554

Watercolour

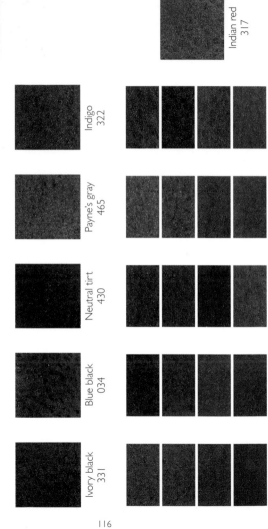

Indian red
317

Indigo
322

Payne's gray
465

Neutral tirt
430

Blue black
034

Ivory black
331

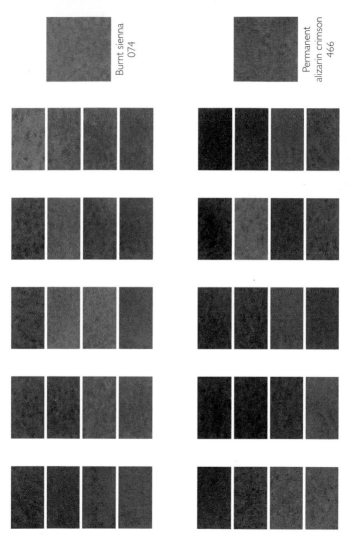

Burnt sienna
074

Permanent
alizarin crimson
466

Watercolour

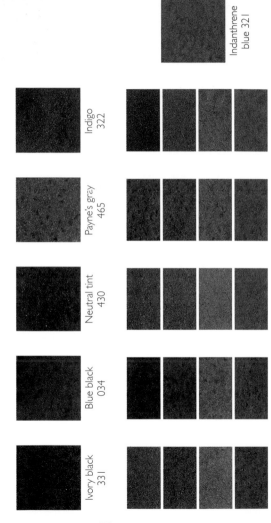

Indanthrene blue 321

Indigo 322

Payne's grey 465

Neutral tint 430

Blue black 034

Ivory black 331

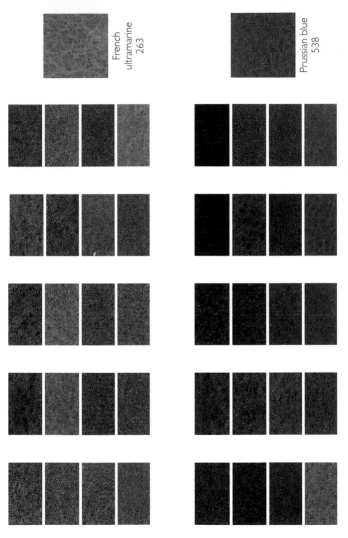

French
ultramarine
263

Prussian blue
538

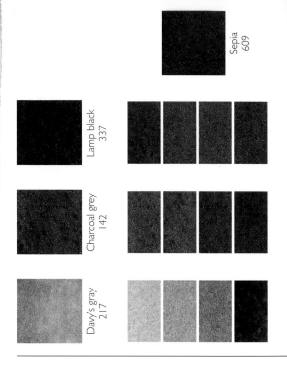

BLACKS AND GREYS FROM OTHER COLOURS **TIP**

You can get blacks and greys straight from the tube, but it is also possible to mix them yourself. Mixing together any combination of red, yellow and blue will produce a shade of grey or black. These shades will depend on the colours you start with, the strength of each colour and the proportions in the mix. The examples here show just a tiny sample of what is possible, experimenting will show you many more.

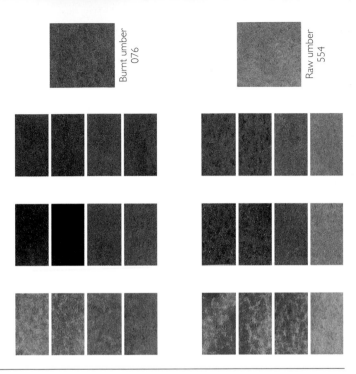

Burnt umber 076

Raw umber 554

Cobalt blue 178,
Raw sienna 552
and Cadmium
red 094

Cobalt blue 178,
Lemon yellow 347
and Cadmium
red 094

Antwerp blue 010,
Indian yellow 319
and Cadmium
red 094

Prussian blue
538 with Indian
red 317

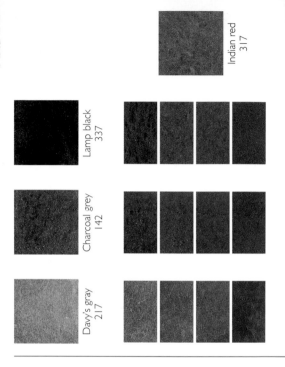

Indian red
317

Lamp black
337

Charcoal grey
142

Davy's gray
217

BLACKS AND GREYS FROM OTHER COLOURS **TIP**

French ultramarine is an excellent base for mixing blacks and greys. Compare the mixes opposite, where Raw sienna with French ultramarine and Cadmium red makes a warm grey, while Lemon yellow with the same colours produces a cooler grey.

A strong mix of French ultramarine and Burnt sienna comes out as almost black.

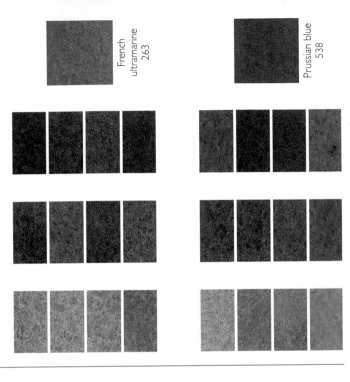

French ultramarine 263

Prussian blue 538

French ultramarine 263, Raw sienna 552 and Cadmium red 094

French ultramarine 263, Lemon yellow 347 and Cadmium red 094

French ultramarine 263 with Burnt sienna 074

Winsor blue red shade 709 with Burnt sienna 074

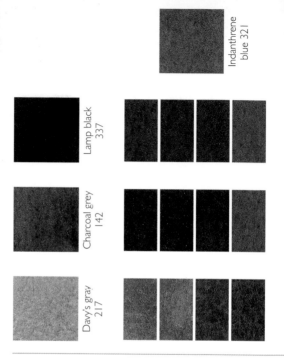

Indanthrene blue 321

Lamp black 337

Charcoal grey 142

Davy's gray 217

PALE GREYS **TIP**

To obtain these very pale greys you will need to produce a very dilute and watery mix; compare these mixes with the stronger and darker mixes on pages 121 and 123. You could experiment by working with a limited palette: using the very pale greys opposite and contrasting them with some darker mixes could produce some interesting results.

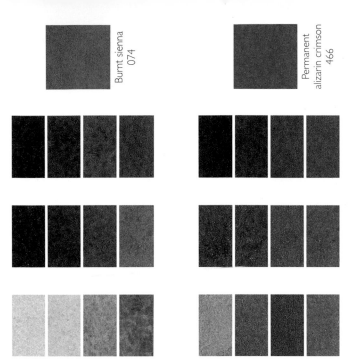

Burnt sienna
074

Permanent
alizarin crimson
466

Cobalt blue
178 with
Cadmium red
094 and Raw
sienna 552

Cobalt blue
178 with
Cadmium red
094 and Lemon
yellow 347

Antwerp
blue 010 with
Cadmium red
094 and Indian
yellow 319

French
ultramarine
263 with Burnt
sienna 074

Prussian blue
538 with Indian
red 317

Watercolour
diluted with water

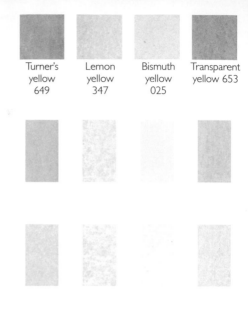

Turner's yellow 649

Lemon yellow 347

Bismuth yellow 025

Transparent yellow 653

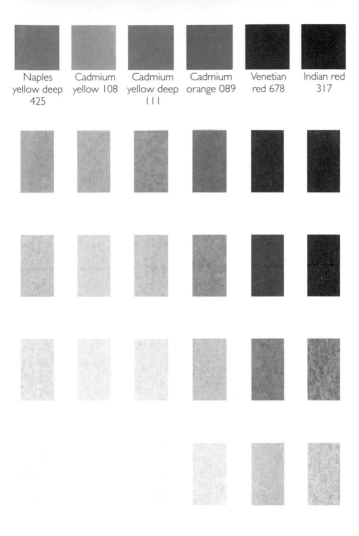

| Naples yellow deep 425 | Cadmium yellow 108 | Cadmium yellow deep 111 | Cadmium orange 089 | Venetian red 678 | Indian red 317 |

Watercolour
diluted with water

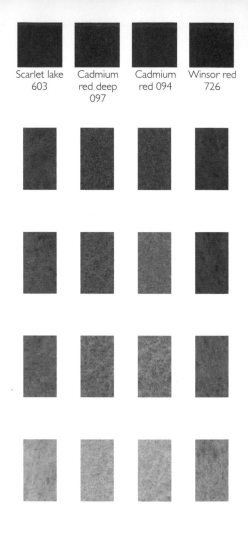

Scarlet lake
603

Cadmium
red deep
097

Cadmium
red 094

Winsor red
726

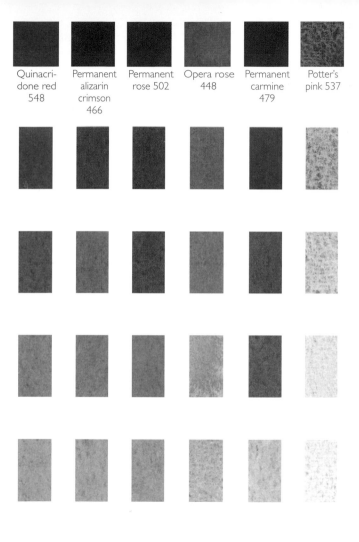

| Quinacridone red 548 | Permanent alizarin crimson 466 | Permanent rose 502 | Opera rose 448 | Permanent carmine 479 | Potter's pink 537 |

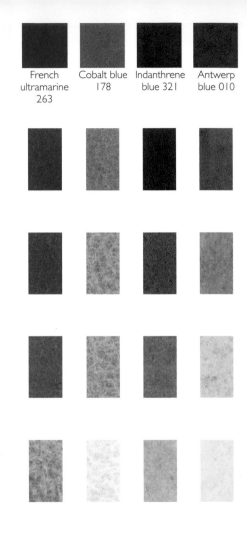

French
ultramarine
263

Cobalt blue
178

Indanthrene
blue 321

Antwerp
blue 010

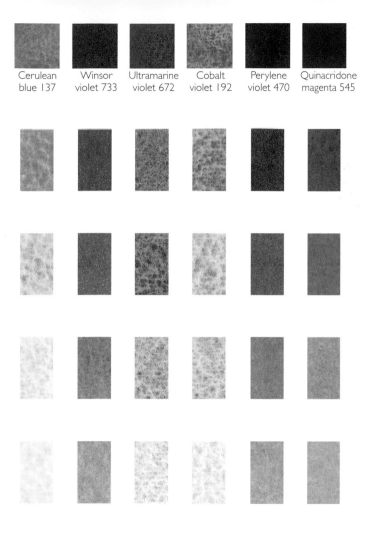

| Cerulean blue 137 | Winsor violet 733 | Ultramarine violet 672 | Cobalt violet 192 | Perylene violet 470 | Quinacridone magenta 545 |

Watercolour
diluted with water

Cobalt turquoise 190

Cobalt green 184

Winsor green yellow shade 721

Winsor green blue shade 719

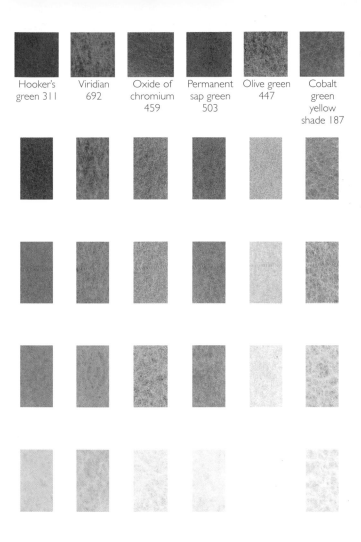

Hooker's green 311

Viridian 692

Oxide of chromium 459

Permanent sap green 503

Olive green 447

Cobalt green yellow shade 187

Watercolour
diluted with water

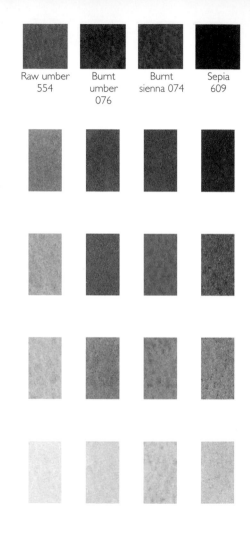

Raw umber 554

Burnt umber 076

Burnt sienna 074

Sepia 609

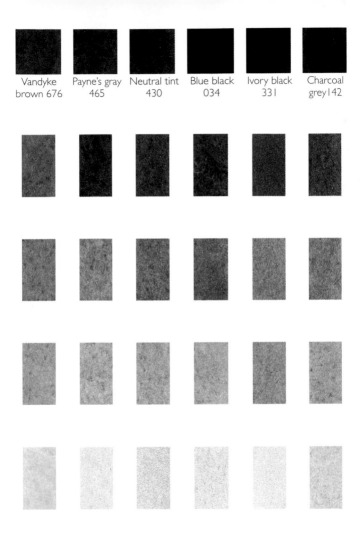

| Vandyke brown 676 | Payne's gray 465 | Neutral tint 430 | Blue black 034 | Ivory black 331 | Charcoal grey142 |

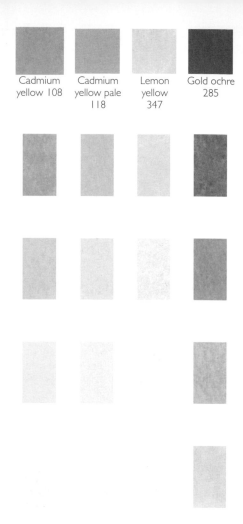

Watercolour
mixed with chinese white

Cadmium yellow 108

Cadmium yellow pale 118

Lemon yellow 347

Gold ochre 285

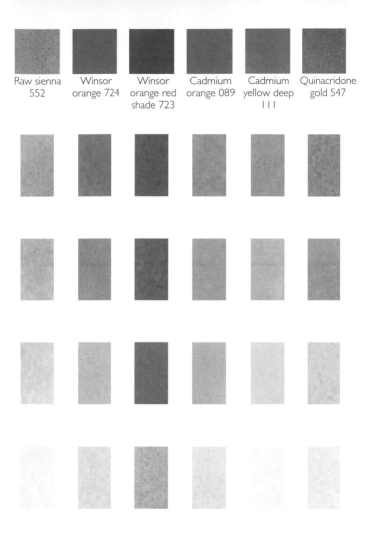

Raw sienna
552

Winsor
orange 724

Winsor
orange red
shade 723

Cadmium
orange 089

Cadmium
yellow deep
111

Quinacridone
gold 547

Watercolour
mixed with chinese white

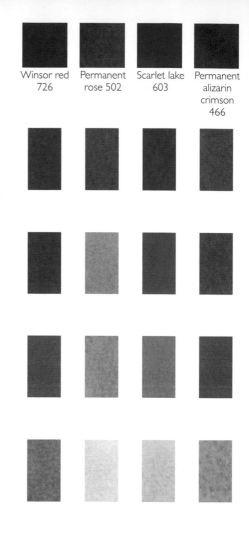

Winsor red 726

Permanent rose 502

Scarlet lake 603

Permanent alizarin crimson 466

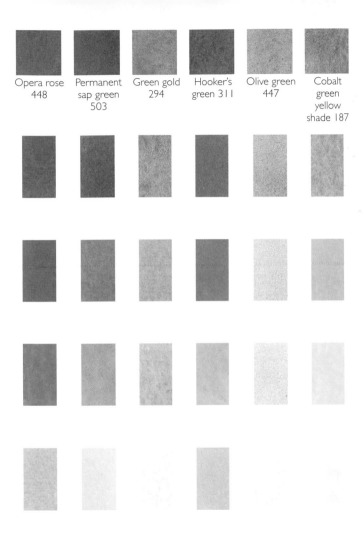

| Opera rose 448 | Permanent sap green 503 | Green gold 294 | Hooker's green 311 | Olive green 447 | Cobalt green yellow shade 187 |

Watercolour
mixed with chinese white

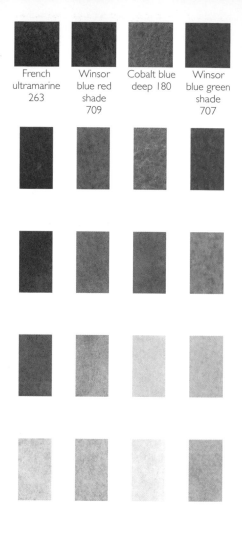

French ultramarine 263

Winsor blue red shade 709

Cobalt blue deep 180

Winsor blue green shade 707

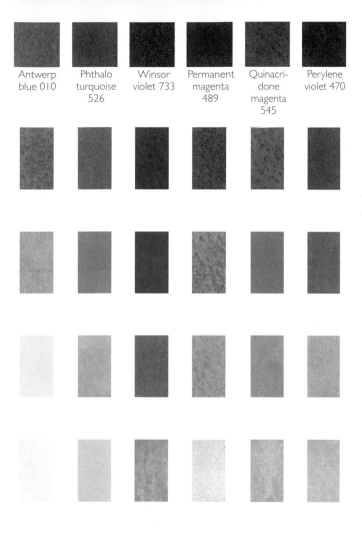

Antwerp blue 010

Phthalo turquoise 526

Winsor violet 733

Permanent magenta 489

Quinacridone magenta 545

Perylene violet 470

Brown
ochre 059

Burnt
sienna 074

Sepia
609

Magnesium
brown 381

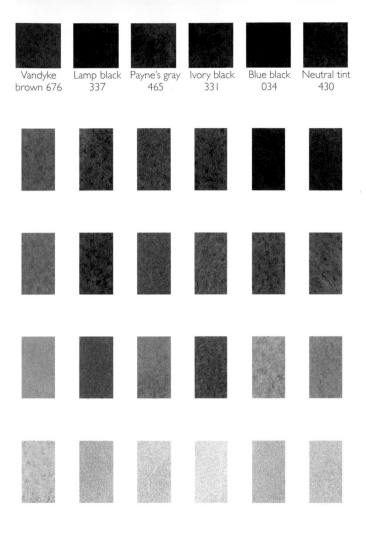

Vandyke
brown 676

Lamp black
337

Payne's gray
465

Ivory black
331

Blue black
034

Neutral tint
430

OIL

Oil paint was first developed in the fifteenth century. Oil paint consists of a pigment suspended in a binder, generally linseed oil. The paint has a thick, buttery consistency and is extremely versatile, offering artists a broad range of rich, robust and durable colours.

Oil paint offers the artist a huge range of textures; it can be used straight from the tube and applied thickly with a brush or with a palette knife, and when the paint dries its texture will retain the brush- or knife-marks. Oil paint can also be thinned

with a solvent such as turpentine or white spirit, and applied in thinner, more translucent, washes of colour.

In contrast to acrylic paint, oil paint remains wet for several days after being applied, and can be worked and reworked during this time. Depending on the pigment, the paint can take between two and twelve days to become touch-dry. However, drying mediums can be added to the paint to speed up the drying time considerably.

Oil paint is usually applied to canvas or canvas boards. Heavyweight watercolour paper can also be used, but it needs to be adequately sized and primed first to prepare it.

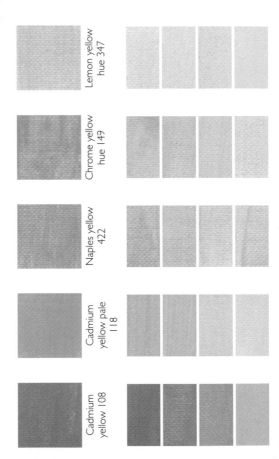

Oil

Bismuth
yellow 025

Lemon yellow
hue 347

Chrome yellow
hue 149

Naples yellow
422

Cadmium
yellow pale
118

Cadmium
yellow 108

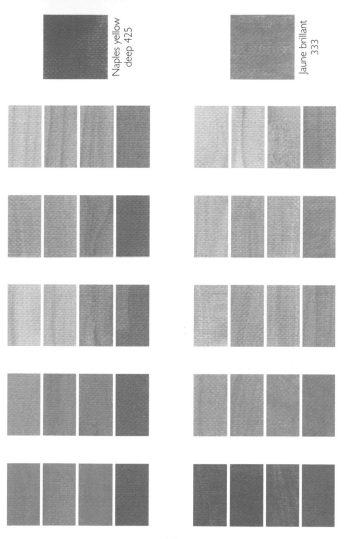

Naples yellow
deep 425

Jaune brillant
333

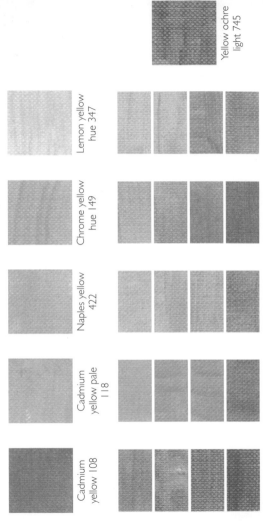

Yellow ochre light 745

Lemon yellow hue 347

Chrome yellow hue 149

Naples yellow 422

Cadmium yellow pale 118

Cadmium yellow 108

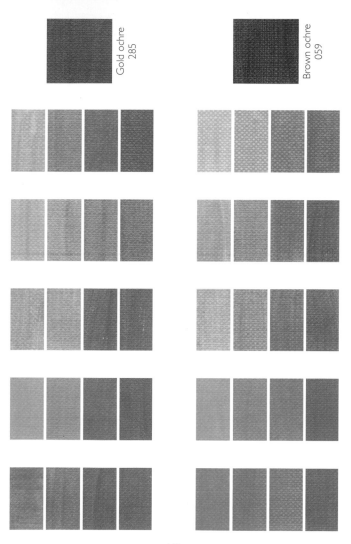

Gold ochre
285

Brown ochre
059

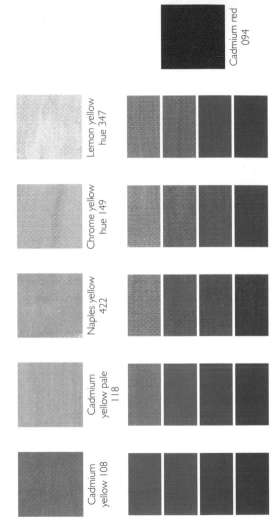

Oil

Cadmium red
094

Lemon yellow
hue 347

Chrome yellow
hue 149

Naples yellow
422

Cadmium
yellow pale
118

Cadmium
yellow 108

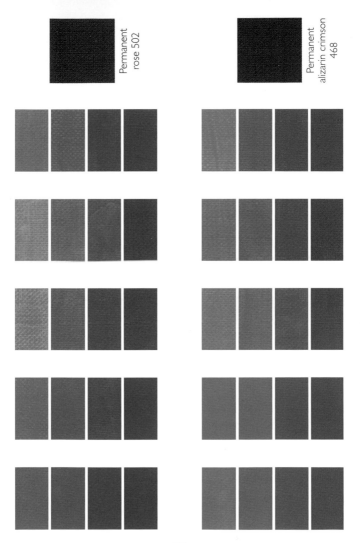

Permanent
rose 502

Permanent
alizarin crimson
468

151

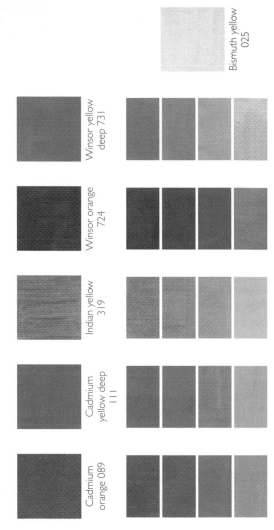

Oil

Bismuth yellow
025

Winsor yellow
deep 731

Winsor orange
724

Indian yellow
319

Cadmium
yellow deep
111

Cadmium
orange 089

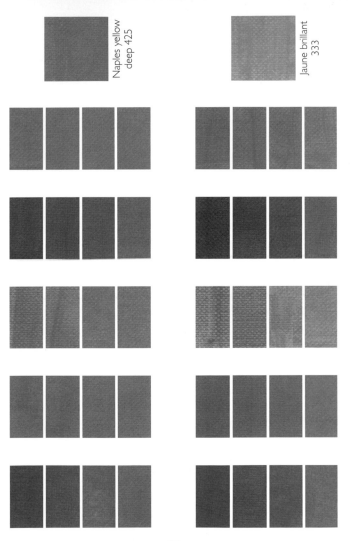

Naples yellow deep 425

Jaune brillant 333

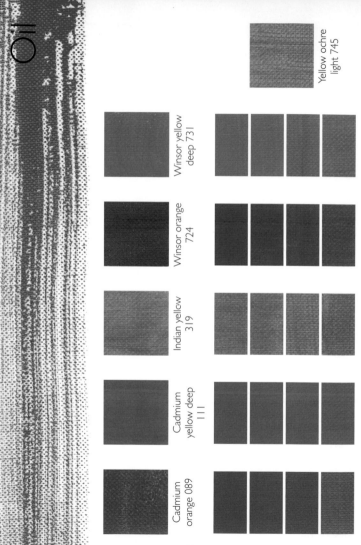

Oil

Yellow ochre
light 745

Winsor yellow
deep 731

Winsor orange
724

Indian yellow
319

Cadmium
yellow deep 111

Cadmium
orange 089

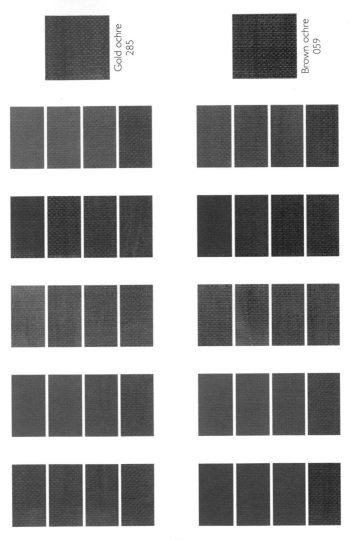

Gold ochre
285

Brown ochre
059

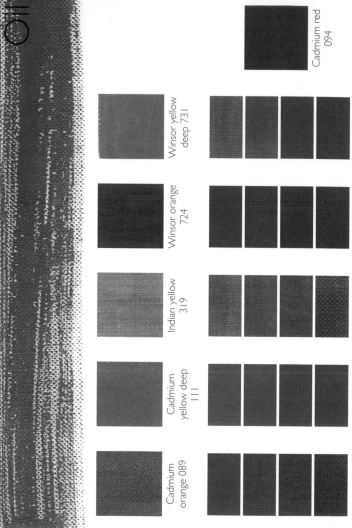

Oil

Cadmium red
094

Winsor yellow
deep 731

Winsor orange
724

Indian yellow
319

Cadmium
yellow deep
111

Cadmium
orange 089

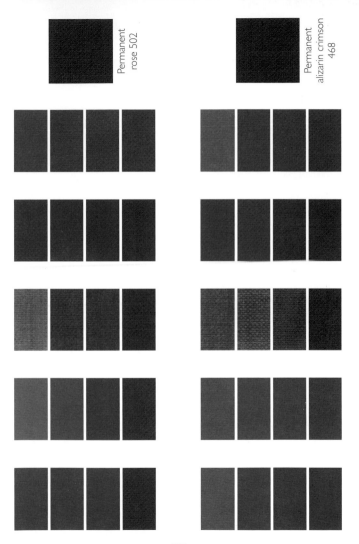

Permanent
rose 502

Permanent
alizarin crimson
468

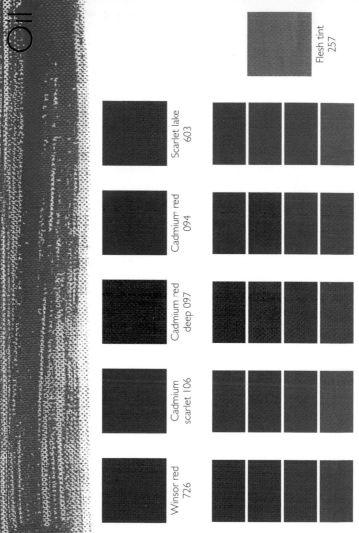

Oil

Flesh tint
257

Scarlet lake
603

Cadmium red
094

Cadmium red
deep 097

Cadmium
scarlet 106

Winsor red
726

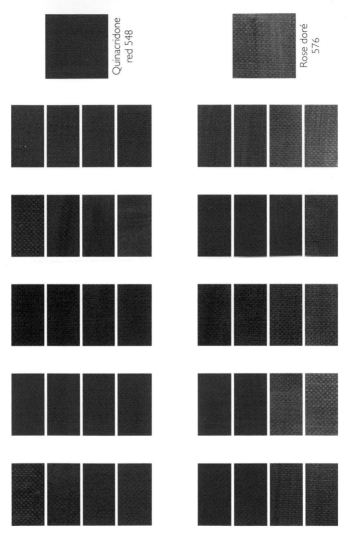

Quinacridone
red 548

Rose doré
576

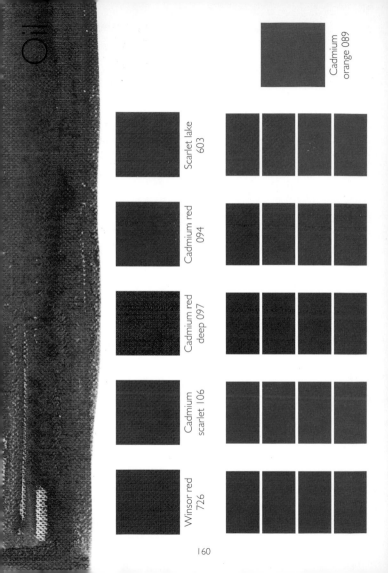

Oil

Cadmium
orange 089

Scarlet lake
603

Cadmium red
094

Cadmium red
deep 097

Cadmium
scarlet 106

Winsor red
726

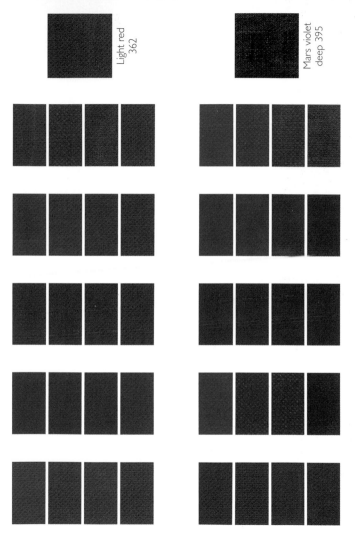

Light red
362

Mars violet
deep 395

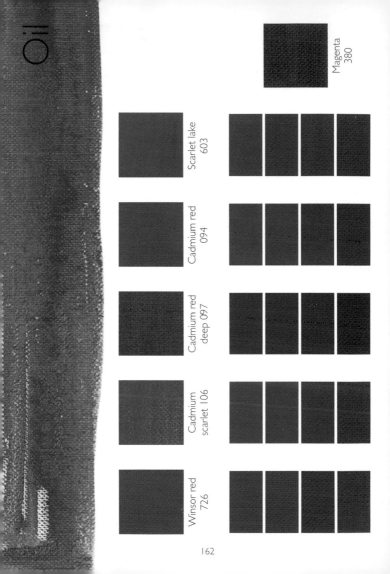

Magenta
380

Scarlet lake
603

Cadmium red
094

Cadmium red
deep 097

Cadmium
scarlet 106

Winsor red
726

162

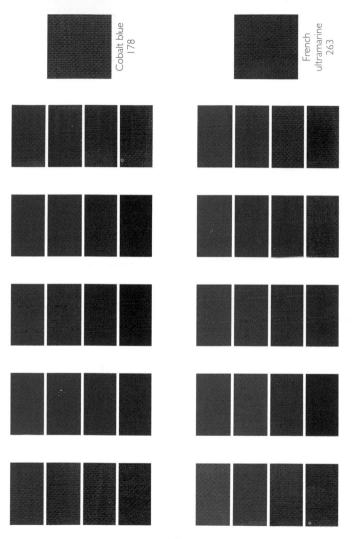

Cobalt blue
178

French
ultramarine
263

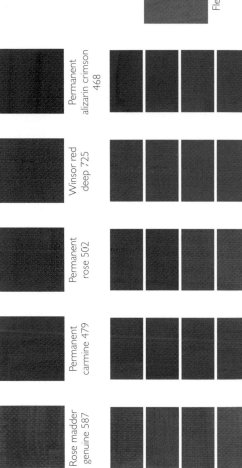

Oil

Flesh tint
257

Permanent
alizarin crimson
468

Winsor red
deep 725

Permanent
rose 502

Permanent
carmine 479

Rose madder
genuine 587

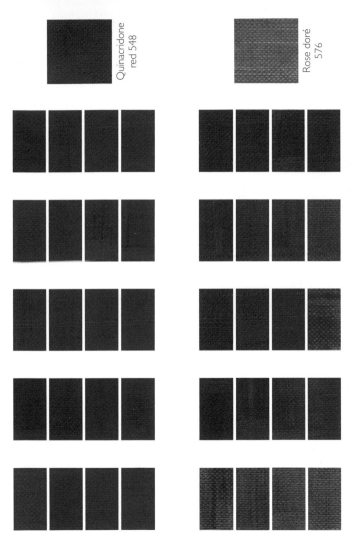

Quinacridone
red 548

Rose doré
576

Oil

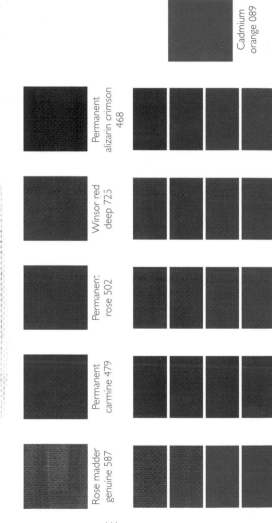

Cadmium orange 089

Permanent alizarin crimson 468

Winsor red deep 725

Permanent rose 502

Permanent carmine 479

Rose madder genuine 587

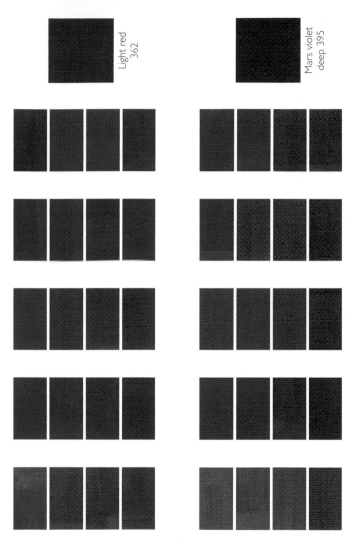

Light red
362

Mars violet
deep 395

oil

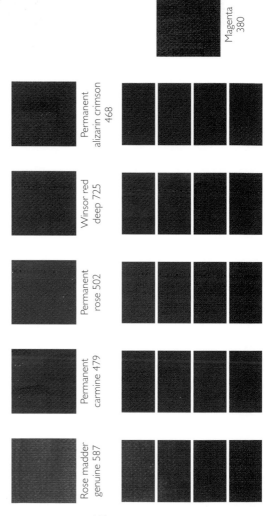

Magenta
380

Permanent
alizarin crimson
468

Winsor red
deep 725

Permanent
rose 502

Permanent
carmine 479

Rose madder
genuine 587

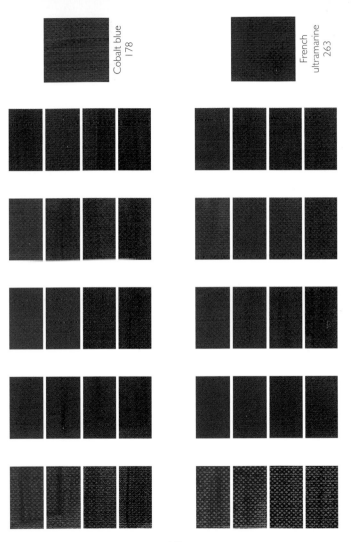

Cobalt blue
178

French
ultramarine
263

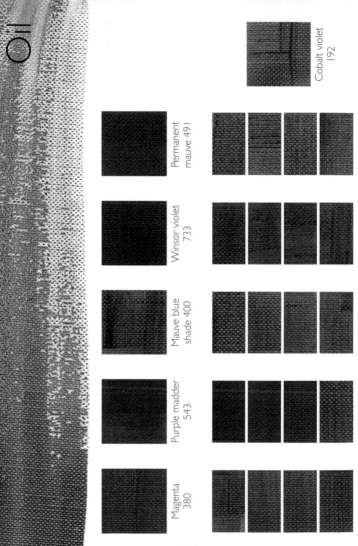

Oil

Cobalt violet
192

Permanent
mauve 491

Winsor violet
733

Mauve blue
shade 400

Purple madder
543

Magenta
380

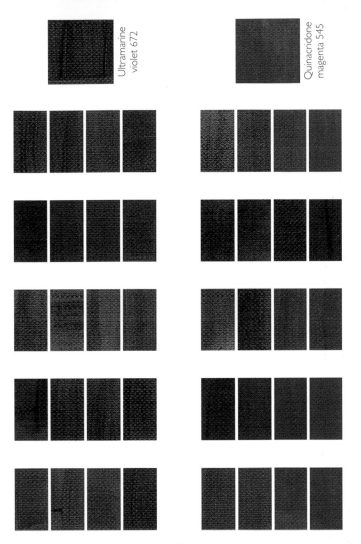

Ultramarine
violet 672

Quinacridone
magenta 545

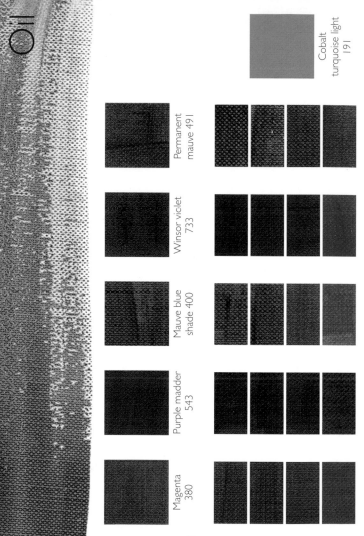

Oil

Cobalt
turquoise light
191

Permanent
mauve 491

Winsor violet
733

Mauve blue
shade 400

Purple madder
543

Magenta
380

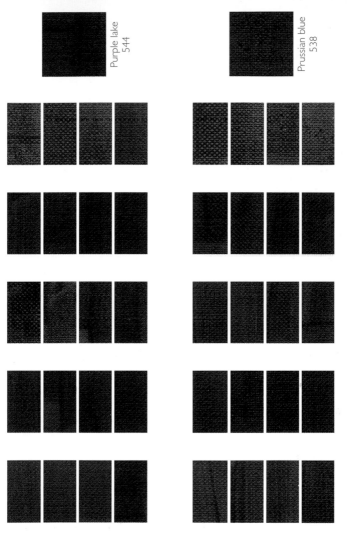

Purple lake
544

Prussian blue
538

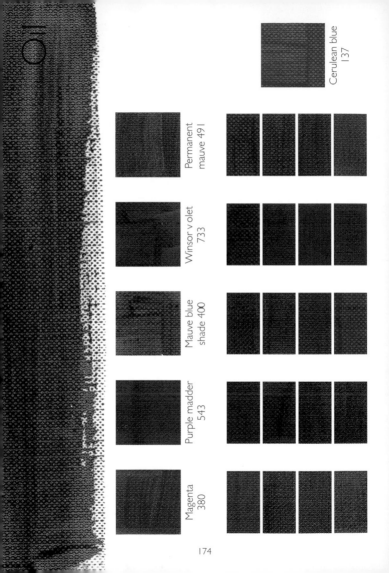

Oil

Cerulean blue
137

Permanent
mauve 491

Winsor violet
733

Mauve blue
shade 400

Purple madder
543

Magenta
380

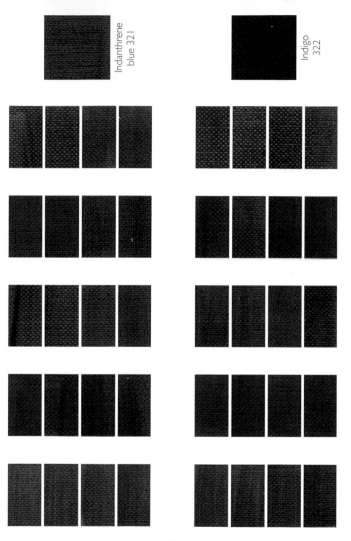

Indanthrene blue 321

Indigo 322

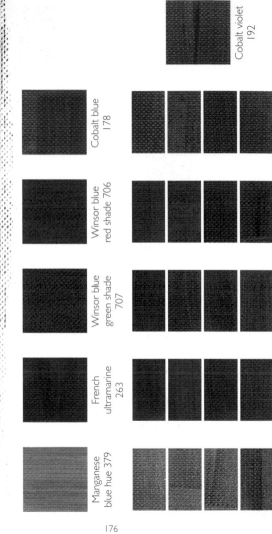

Oil

Cobalt violet
192

Cobalt blue
178

Winsor blue
red shade 706

Winsor blue
green shade
707

French
ultramarine
263

Manganese
blue hue 379

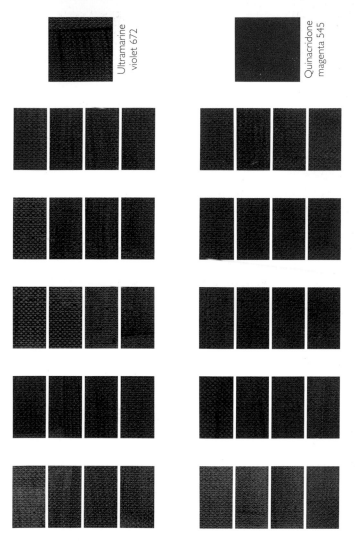

Ultramarine violet 672

Quinacridone magenta 545

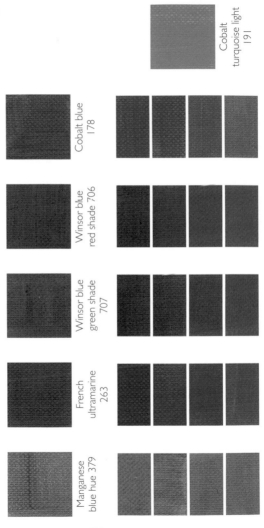

Oil

Cobalt
turquoise light
191

Cobalt blue
178

Winsor blue
red shade 706

Winsor blue
green shade
707

French
ultramarine
263

Manganese
blue hue 379

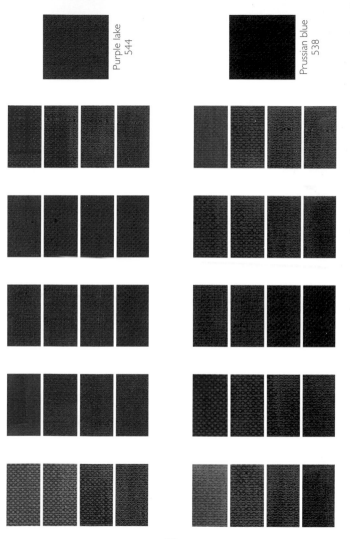

Purple lake
544

Prussian blue
538

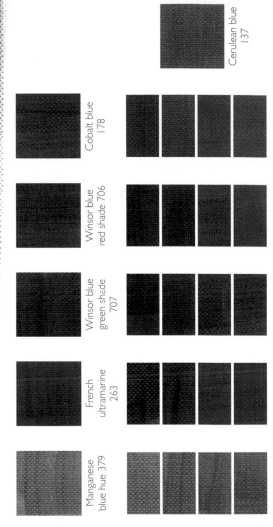

Oil

Cerulean blue
137

Cobalt blue
178

Winsor blue
red shade 706

Winsor blue
green shade
707

French
ultramarine
263

Manganese
blue hue 379

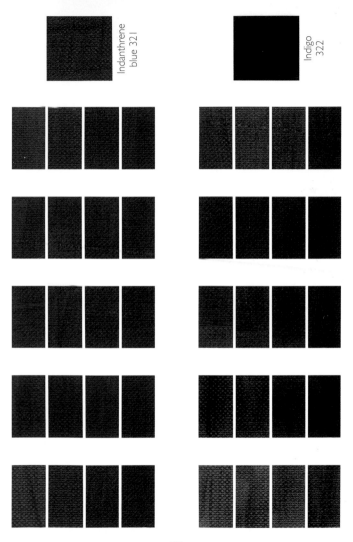

Indanthrene
blue 321

Indigo
322

Oil

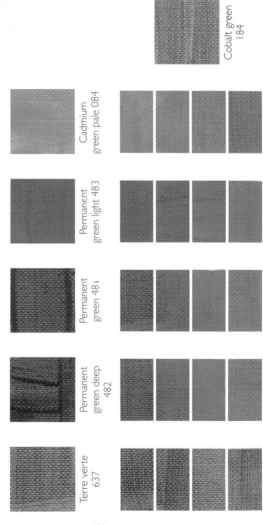

Cobalt green
184

Cadmium
green pale 084

Permanent
green light 483

Permanent
green 481

Permanent
green deep
482

Terre verte
637

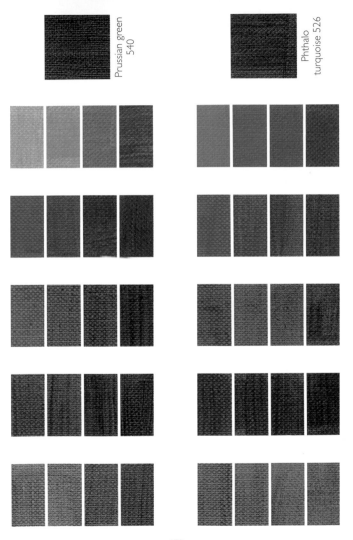

Prussian green
540

Phthalo
turquoise 526

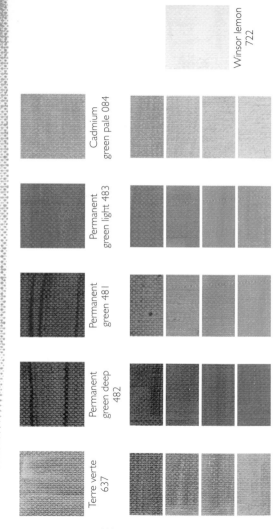

Winsor lemon
722

Cadmium
green pale 084

Permanent
green light 483

Permanent
green 481

Permanent
green deep
482

Terre verte
637

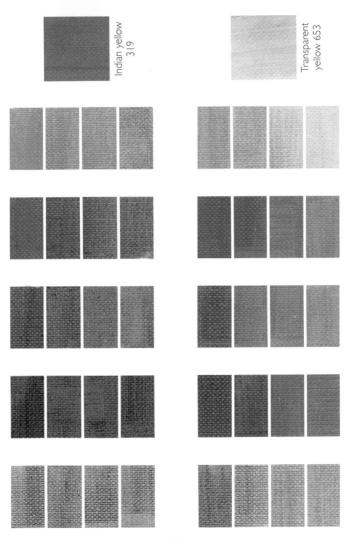

Indian yellow
319

Transparent
yellow 653

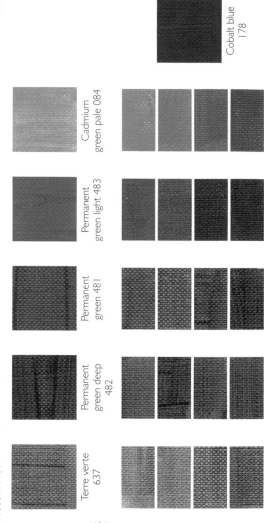

Oil

Cobalt blue
178

Cadmium
green pale 084

Permanent
green light 483

Permanent
green 481

Permanent
green deep
482

Terre verte
637

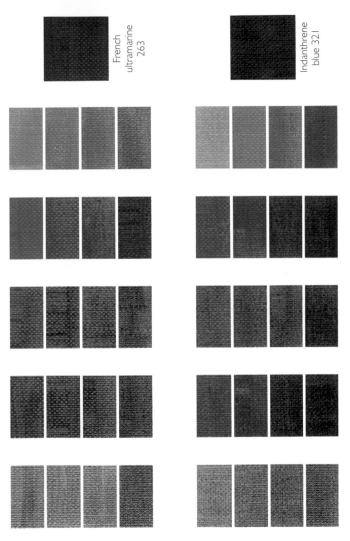

French ultramarine 263

Indanthrene blue 321

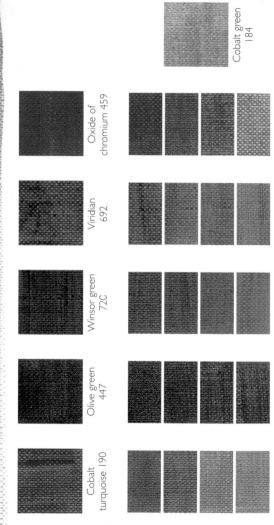

Oil

Cobalt green
184

Oxide of
chromium 459

Viridian
692

Winsor green
72C

Olive green
447

Cobalt
turquoise 190

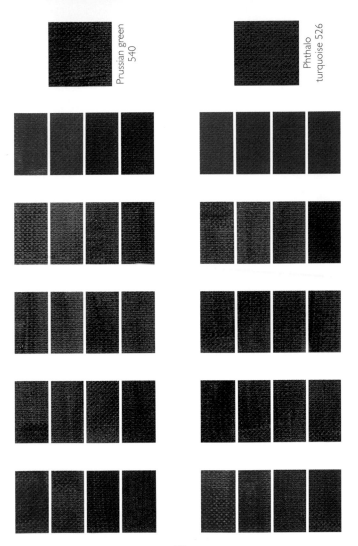

Prussian green
540

Phthalo
turquoise 526

Oil

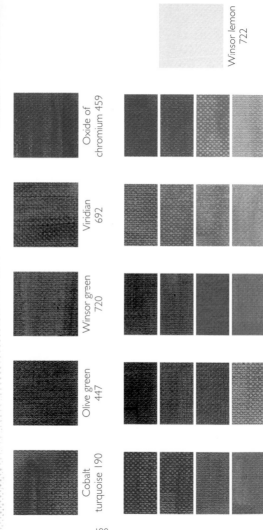

Winsor lemon
722

Oxide of
chromium 459

Viridian
692

Winsor green
720

Olive green
447

Cobalt
turquoise 190

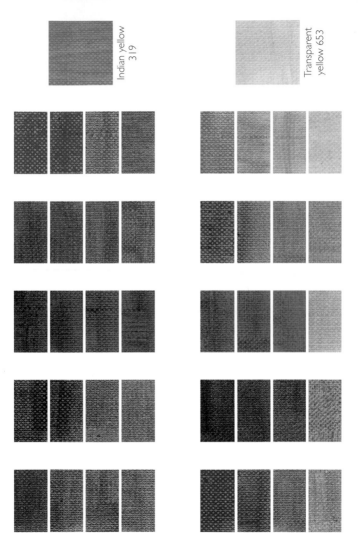

Indian yellow
319

Transparent
yellow 653

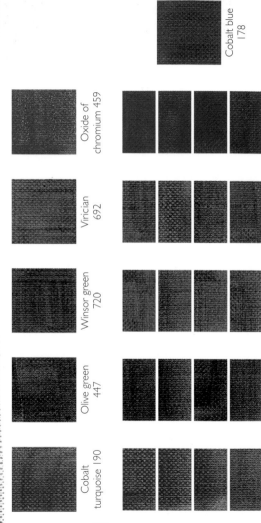

Cobalt blue
178

Oxide of
chromium 459

Viridian
692

Winsor green
720

Olive green
447

Cobalt
turquoise 190

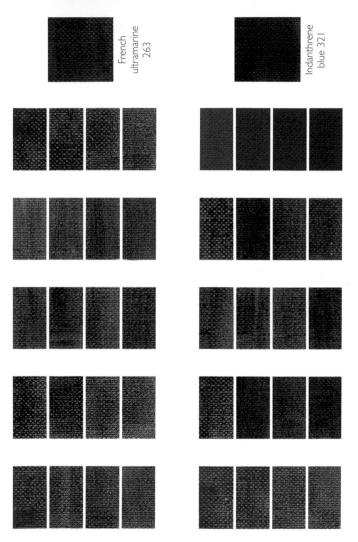

French
ultramarine
263

Indanthrene
blue 321

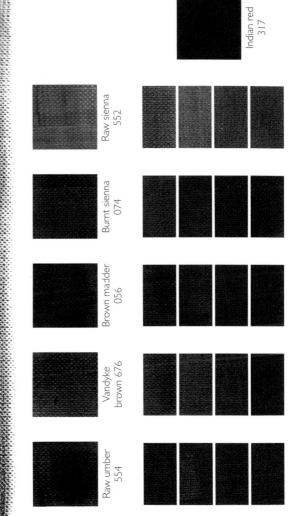

Oil

Indian red
317

Raw sienna
552

Burnt sienna
074

Brown madder
056

Vandyke
brown 676

Raw umber
554

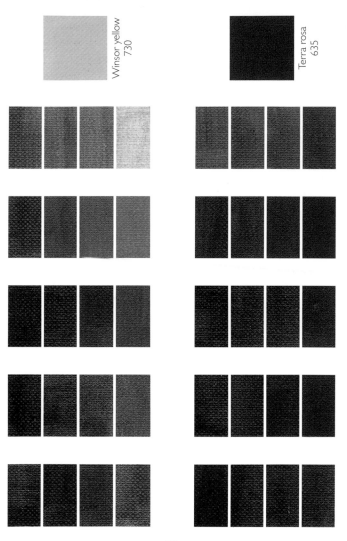

Winsor yellow
730

Terra rosa
635

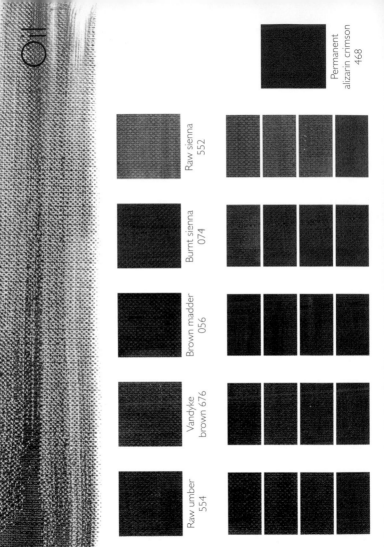

Oil

Permanent
alizarin crimson
468

Raw sienna
552

Burnt sienna
074

Brown madder
056

Vandyke
brown 676

Raw umber
554

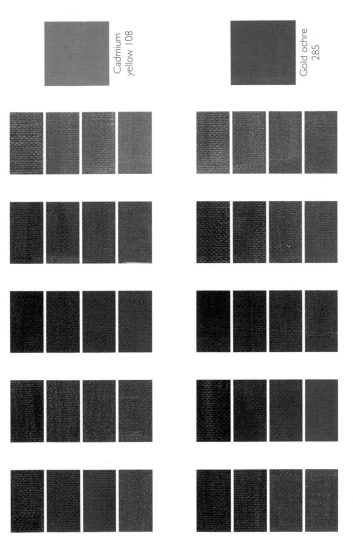

Cadmium yellow 108

Gold ochre 285

Oil

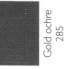

Gold ochre
285

Davy's gray
217

Charcoal grey
142

Payne's grey
465

Blue black
034

Perylene black
505

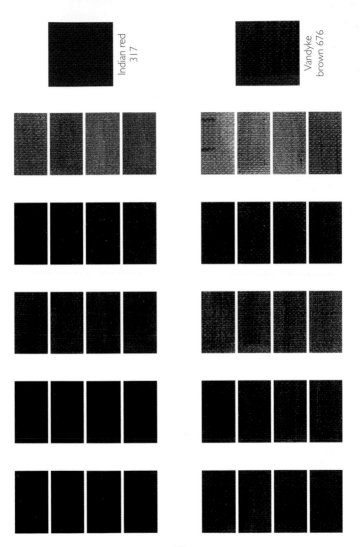

Indian red
317

Vandyke
brown 676

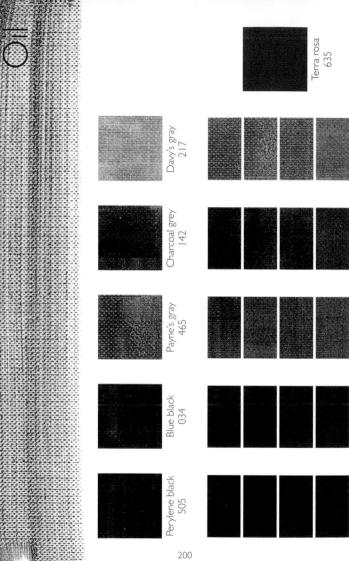

Oil

Terra rosa
635

Davy's gray
217

Charcoal grey
142

Payne's gray
465

Blue black
034

Perylene black
505

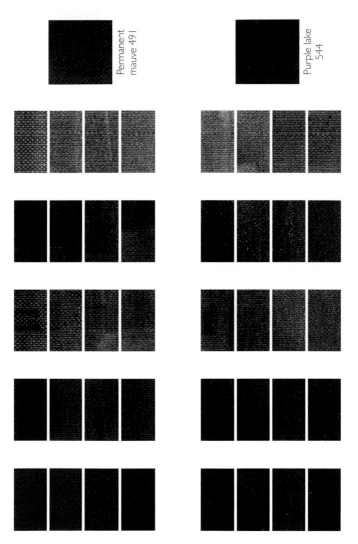

Permanent
mauve 491

Purple lake
544

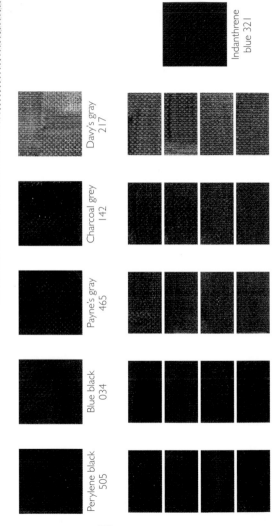

Indanthrene blue 321

Davy's grey 217

Charcoal grey 142

Payne's grey 465

Blue black 034

Perylene black 505

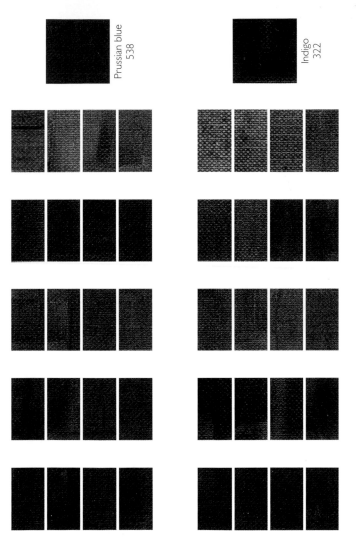

Prussian blue
538

Indigo
322

Oil

mixed with titanium white

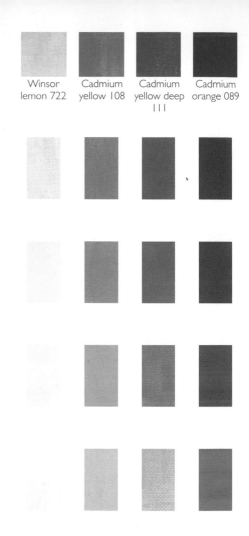

Winsor lemon 722

Cadmium yellow 108

Cadmium yellow deep 111

Cadmium orange 089

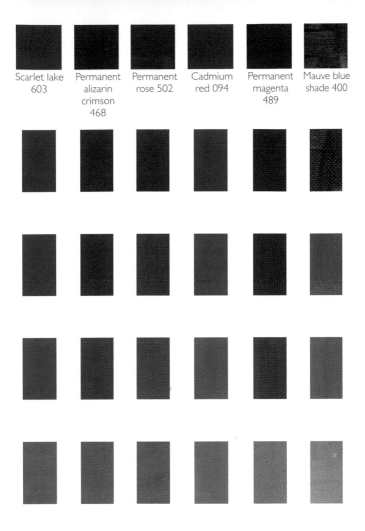

Scarlet lake 603

Permanent alizarin crimson 468

Permanent rose 502

Cadmium red 094

Permanent magenta 489

Mauve blue shade 400

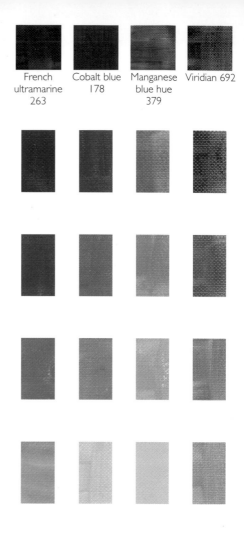

Oil

mixed with titanium white

French
ultramarine
263

Cobalt blue
178

Manganese
blue hue
379

Viridian 692

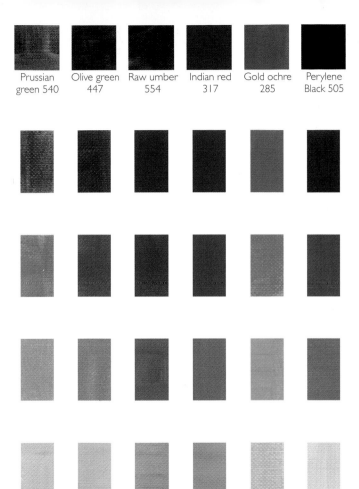

Prussian
green 540

Olive green
447

Raw umber
554

Indian red
317

Gold ochre
285

Perylene
Black 505

ACRYLIC

Acrylic paint was invented during the 1950s and was, arguably, one of the greatest innovations in artists' materials. Acrylic paint is made from a pigment combined with an acrylic binder that dries to form a transparent film. This clear films reflects light from the pigment of the paint, which gives acrylic its characteristic brilliance of colour.

Acrylic is an extremely versatile medium; it can be used like oil paint or like watercolour. Out of the tube, it has a buttery consistency, like oil colour, and will retain brushmarks and palette-knife marks. It offers a similar depth, intensity and

richness of colour as oil paint, but dries much more quickly, making it possible to work over a layer of paint within minutes rather than days. Acrylic can also be mixed with water, so it can be diluted to a watercolour-like consistency and applied in thin washes of colour.

Various acrylic mediums can be added to the paint, such as acrylic retarder, which slows down the drying time, or acrylic fluid matt or gloss medium, both of which are excellent for glazing techniques.

Acrylic can be painted onto canvas using an oil painting-type technique, or can be used on paper by artists using a watercolour-type technique.

Acrylic

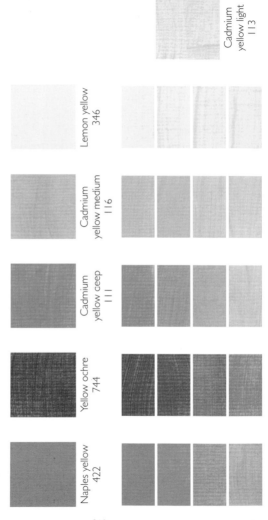

Cadmium yellow light
113

Lemon yellow
346

Cadmium yellow medium
116

Cadmium yellow ceep
111

Yellow ochre
744

Naples yellow
422

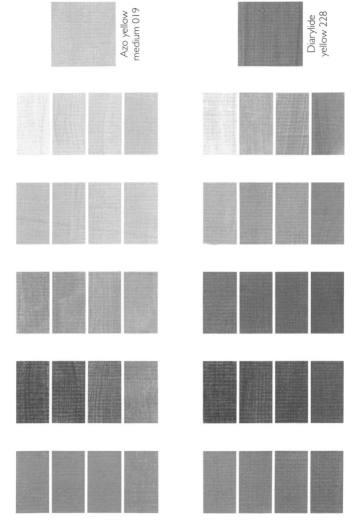

Azo yellow
medium 019

Diarylide
yellow 228

Acrylic

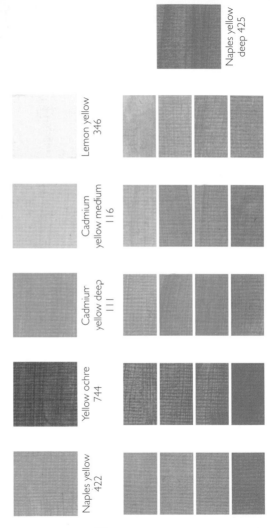

Naples yellow deep 425

Lemon yellow 346

Cadmium yellow medium 116

Cadmium yellow deep 111

Yellow ochre 744

Naples yellow 422

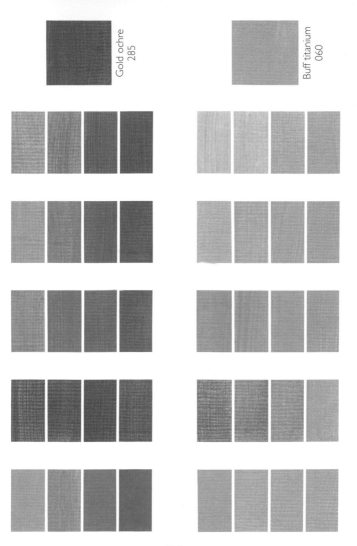

Gold ochre
285

Buff titanium
060

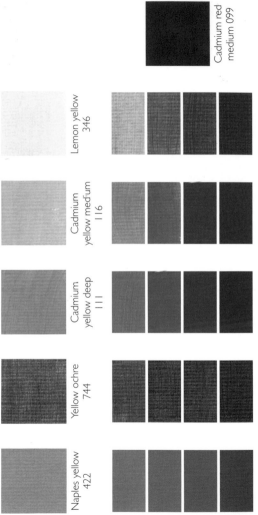

Acrylic

Cadmium red
medium 099

Lemon yellow
346

Cadmium
yellow medium
116

Cadmium
yellow deep
111

Yellow ochre
744

Naples yellow
422

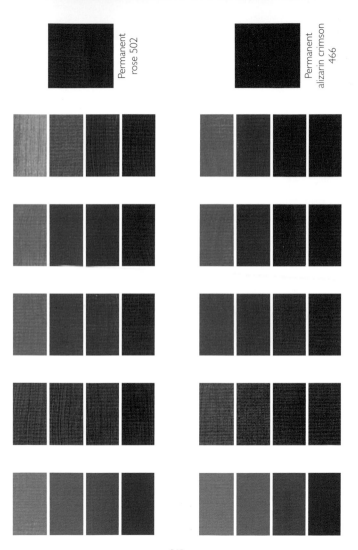

Permanent rose 502

Permanent alizarin crimson 466

Acrylic

Cadmium yellow light
113

Cadmium red
light 100

Cadmium
orange 089

Benzimidazolone
orange 023

Perinone
orange 462

Mars orange
390

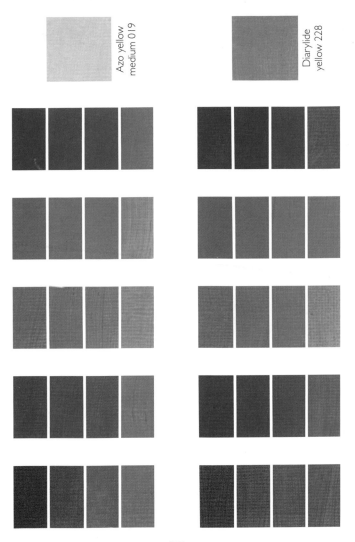

Azo yellow
medium 019

Diarylide
yellow 228

217

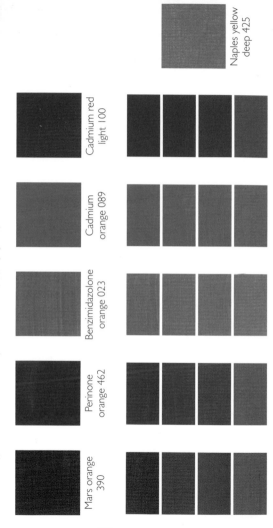

Acrylic

Naples yellow deep 425

Cadmium red light 100

Cadmium orange 089

Benzimidazolone orange 023

Perinone orange 462

Mars orange 390

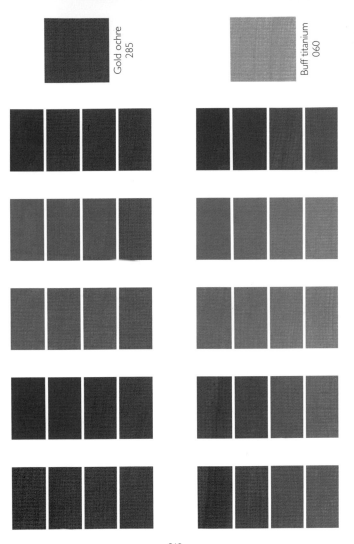

Gold ochre
285

Buff titanium
060

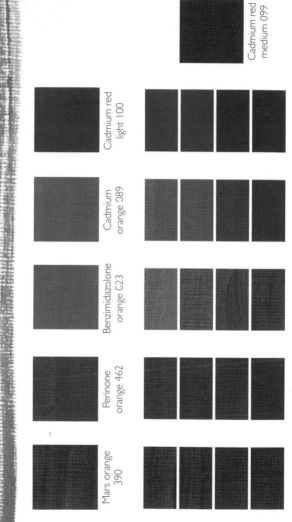

Acrylic

Cadmium red medium 099

Cadmium red light 100

Cadmium orange 089

Benzimidazolone orange C23

Perinone orange 462

Mars orange 390

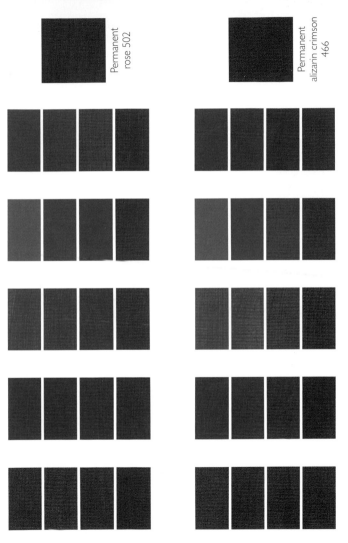

Permanent rose 502

Permanent alizarin crimson 466

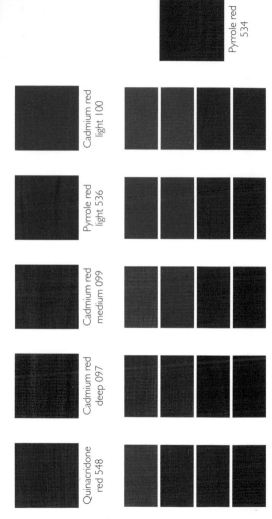

Acrylic

Pyrrole red
534

Cadmium red
light 100

Pyrrole red
light 536

Cadmium red
medium 099

Cadmium red
deep 097

Quinacridone
red 548

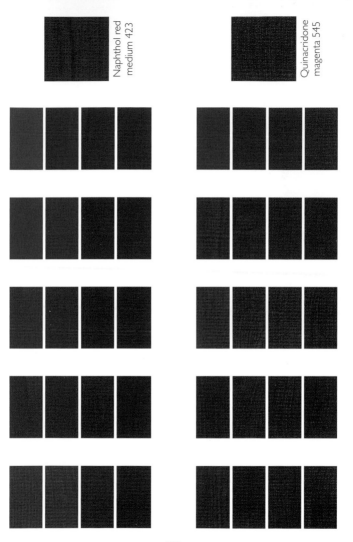

Naphthol red medium 423

Quinacridone magenta 545

Acrylic

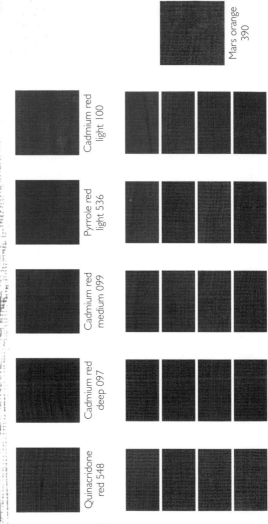

Mars orange
390

Cadmium red
light 100

Pyrrole red
light 536

Cadmium red
medium 099

Cadmium red
deep 097

Quinacridone
red 548

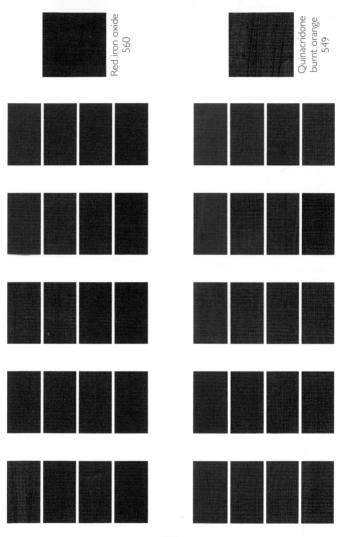

Red iron oxide
560

Quinacridone
burnt orange
549

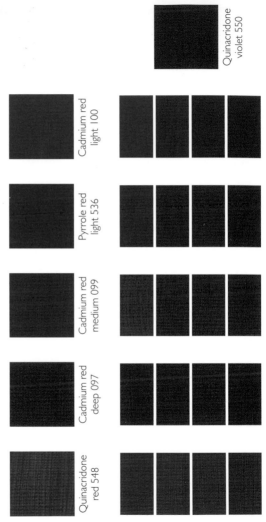

Acrylic

Quinacridone violet 550

Cadmium red light 100

Pyrrole red light 536

Cadmium red medium 099

Cadmium red deep 097

Quinacridone red 548

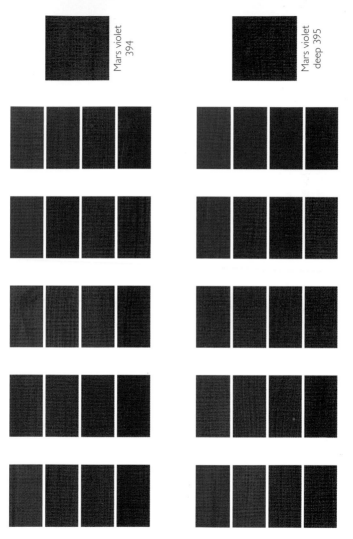

Mars violet
394

Mars violet
deep 395

Acrylic

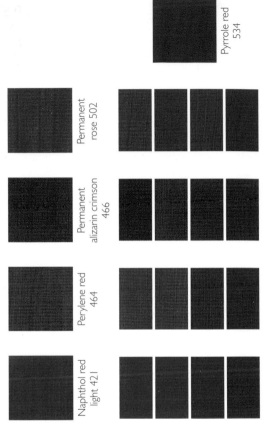

Pyrrole red
534

Permanent
rose 502

Permanent
alizarin crimson
466

Perylene red
464

Naphthol red
light 421

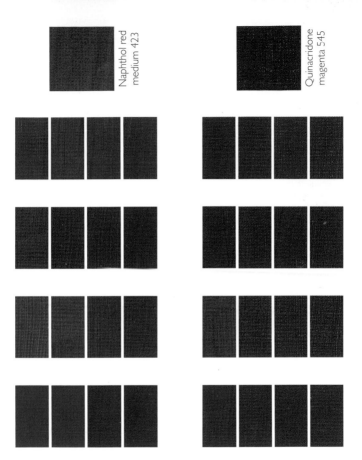

Naphthol red medium 423

Quinacridone magenta 545

Acrylic

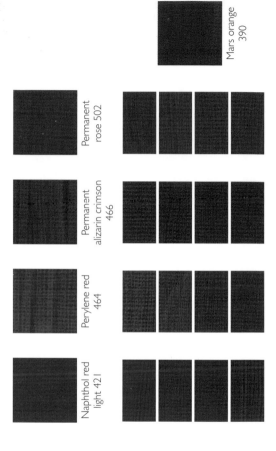

Mars orange
390

Permanent
rose 502

Permanent
alizarin crimson
466

Perylene red
464

Naphthol red
light 421

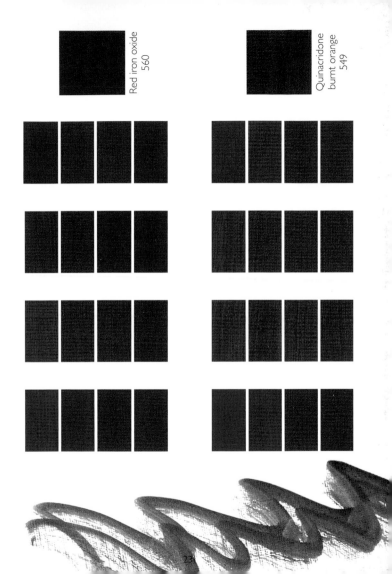

Red iron oxide
560

Quinacridone
burnt orange
549

Acrylic

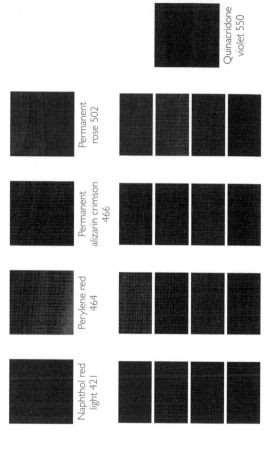

Quinacridone violet 550

Permanent rose 502

Permanent alizarin crimson 466

Perylene red 464

Naphthol red light 421

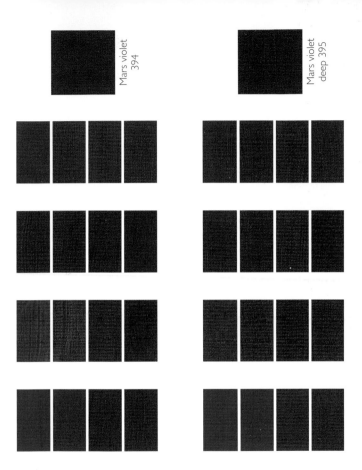

Mars violet 394

Mars violet deep 395

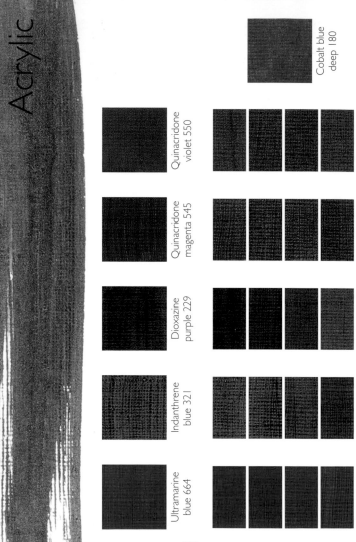

Acrylic

Cobalt blue
deep 180

Quinacridone
violet 550

Quinacridone
magenta 545

Dioxazine
purple 229

Indanthrene
blue 321

Ultramarine
blue 664

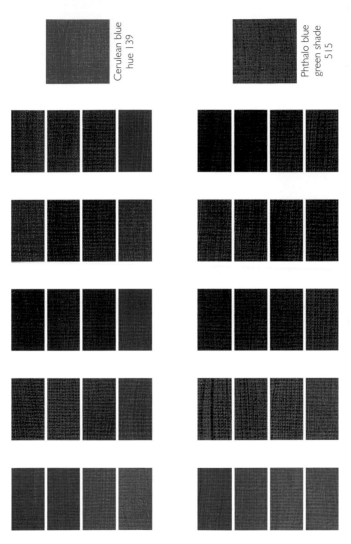

Cerulean blue
hue 139

Phthalo blue
green shade
515

Acrylic

Phthalo
turquoise 526

Quinacridone
violet 550

Quinacridone
magenta 545

Dioxazine
purple 229

Indanthrene
blue 321

Ultramarine
blue 664

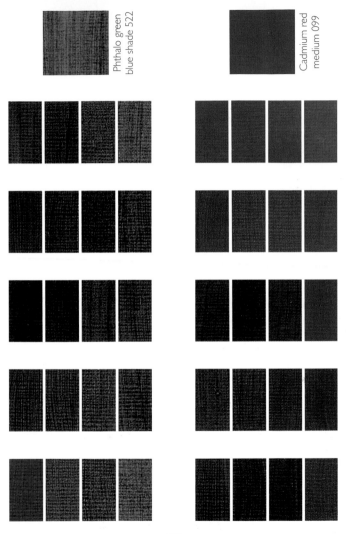

Phthalo green
blue shade 522

Cadmium red
medium 099

Acrylic

Permanent
rose 502

Quinacridone
violet 550

Quinacridone
magenta 545

Dioxazine
purple 229

Indanthrene
blue 321

Ultramarine
blue 664

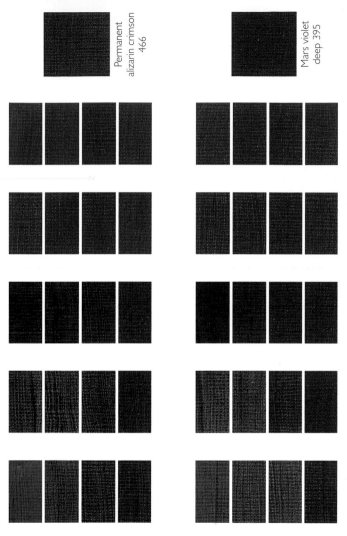

Permanent
alizarin crimson
466

Mars violet
deep 395

239

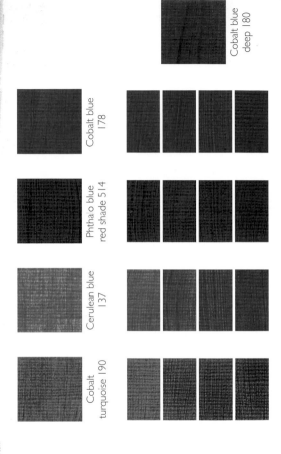

Acrylic

Cobalt blue deep 180

Cobalt blue 178

Phthalo blue red shade 514

Cerulean blue 137

Cobalt turquoise 190

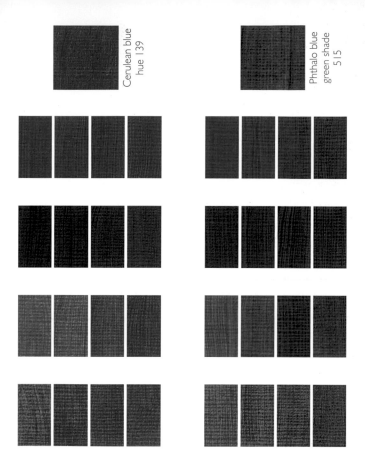

Cerulean blue
hue 139

Phthalo blue
green shade
515

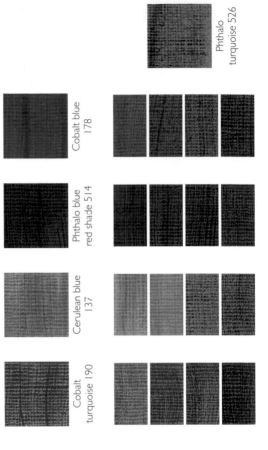

Acrylic

Phthalo turquoise 526

Cobalt blue 178

Phthalo blue red shade 514

Cerulean blue 137

Cobalt turquoise 190

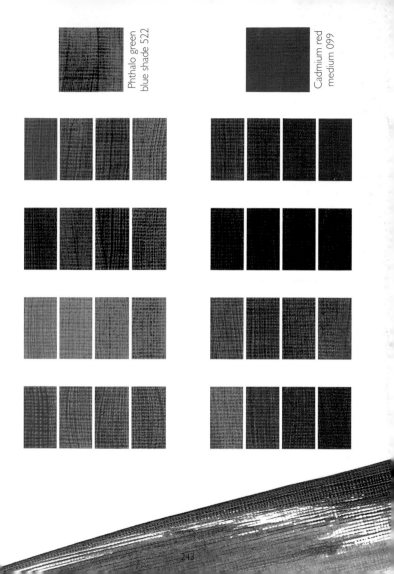

Phthalo green blue shade 522

Cadmium red medium 099

Acrylic

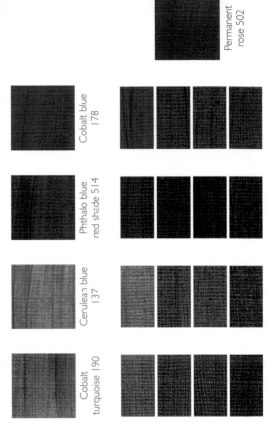

Permanent rose 502

Cobalt blue 178

Phthalo blue red shade 514

Cerulean blue 137

Cobalt turquoise 190

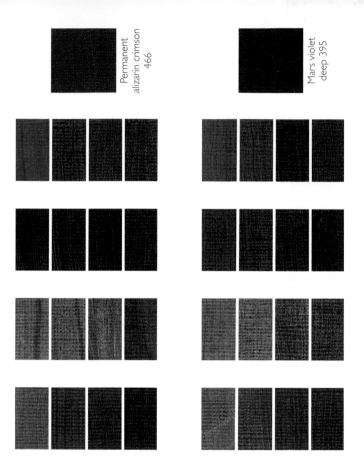

Permanent
alizarin crimson
466

Mars violet
deep 395

Acrylic

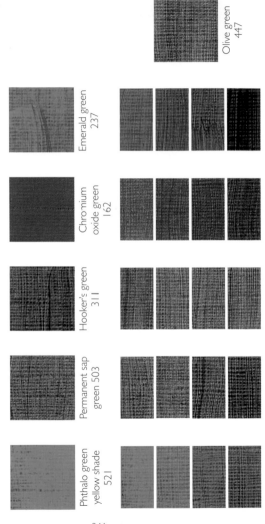

Olive green
447

Emerald green
237

Chromium
oxide green
162

Hooker's green
311

Permanent sap
green 503

Phthalo green
yellow shade
521

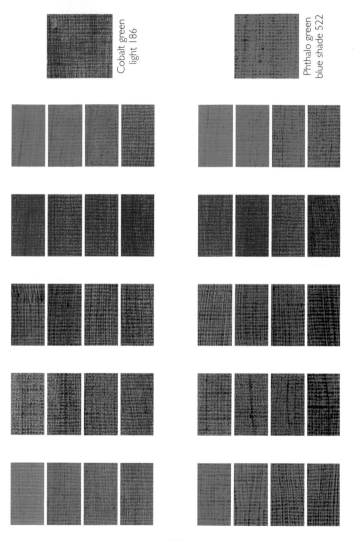

Cobalt green
light 186

Phthalo green
blue shade 522

Acrylic

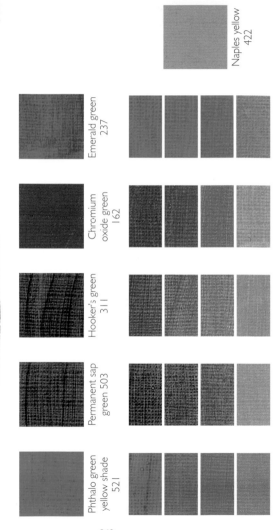

Naples yellow
422

Emerald green
237

Chromium
oxide green
162

Hooker's green
311

Permanent sap
green 503

Phthalo green
yellow shade
521

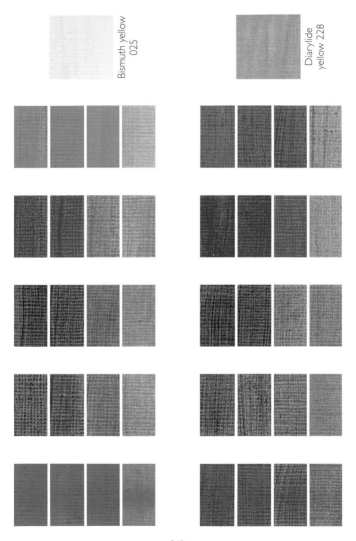

Bismuth yellow 025

Diarylide yellow 228

249

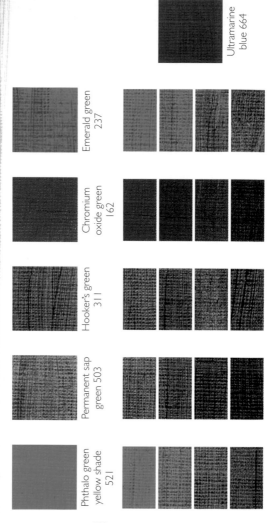

Acrylic

Ultramarine blue 664

Emerald green 237

Chromium oxide green 162

Hooker's green 311

Permanent sap green 503

Phthalo green yellow shade 521

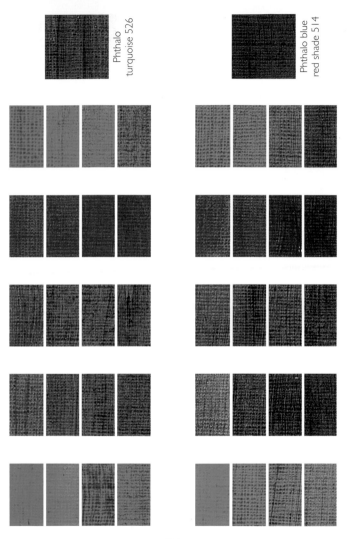

Phthalo
turquoise 526

Phthalo blue
red shade 514

Acrylic

Naples yellow
deep 425

Raw sienna
552

Burnt sienna
074

Raw umber
554

Burnt umber
076

Mars violet
deep 395

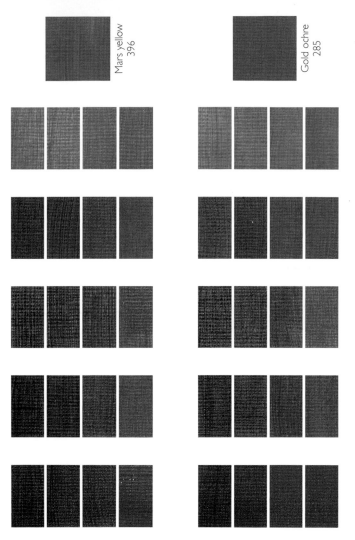

Mars yellow
396

Gold ochre
285

Acrylic

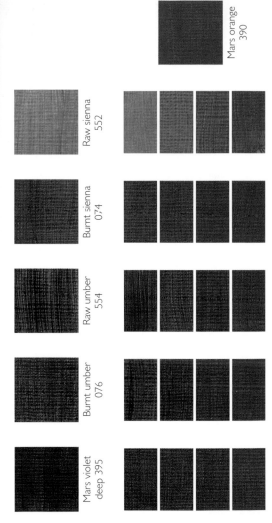

Mars orange
390

Raw sienna
552

Burnt sienna
074

Raw umber
554

Burnt umber
076

Mars violet
deep 395

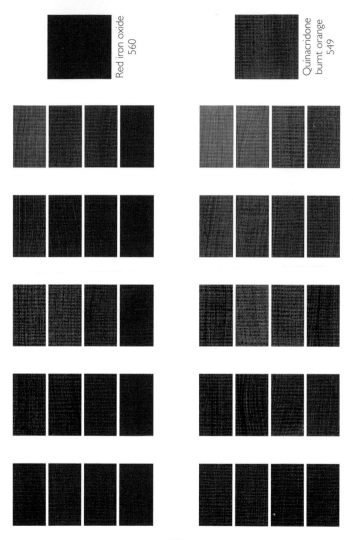

Red iron oxide
560

Quinacridone
burnt orange
549

255

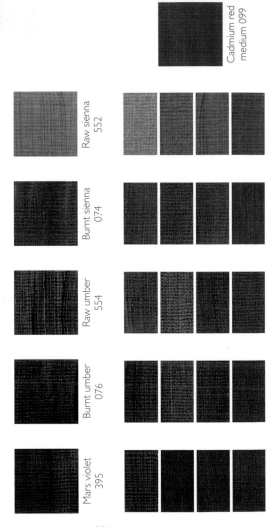

Acrylic

Cadmium red
medium 099

Raw sienna
552

Burnt sienna
074

Raw umber
554

Burnt umber
076

Mars violet
395

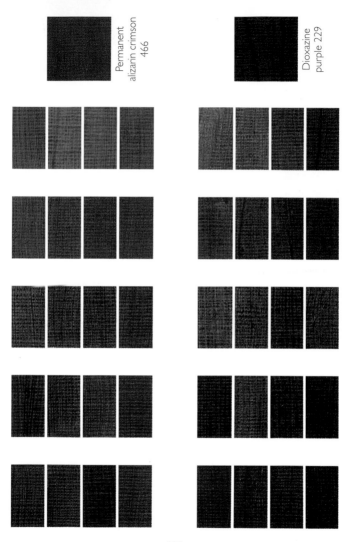

Permanent alizarin crimson 466

Dioxazine purple 229

Ultramarine blue 664

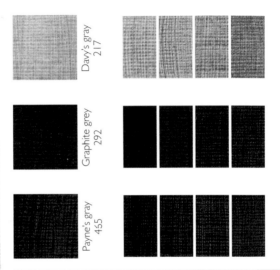

Davy's gray 217

Graphite grey 292

Payne's gray 455

ACRYLIC MEDIUMS THAT ALTER TEXTURE
TIP

Acrylic is a particularly versatile material, and there
are a number of mediums available specifically for use
with acrylics that allow you to increase your creative
opportunities. For example, you can add various gels to
change the texture of the paint to add visual texture and
interest to the painted surface. These gels include pumice,
natural sand, black flint and glass beads.

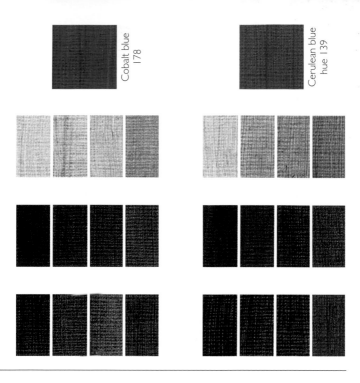

Cobalt blue
178

Cerulean blue
hue 139

Here, Natural Pumice Texture Gel has been blended with an acrylic paint mix to add a fine, slightly gritty texture to the paint. Texture gels allow you to create thick layers of paint and experiment with surface finishes.

Cadmium red deep 097

Davy's gray 217

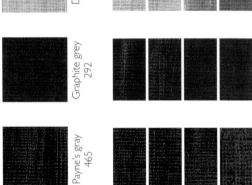

Graphite grey 292

Payne's gray 465

ACRYLIC MEDIUMS THAT HELP PAINT FLOW **TIP**

One of the benefits of acrylic is that it can be mixed with water. However, many artists like to exploit the oil paint-like consistency of acrylic rather than watering it down, and there are mediums available that enhance this quality. *Winsor & Newton* Acrylic Flow Improver is excellent as it doesn't dilute the colour strength, but helps paint flow and is ideal for covering large areas with flat colour.

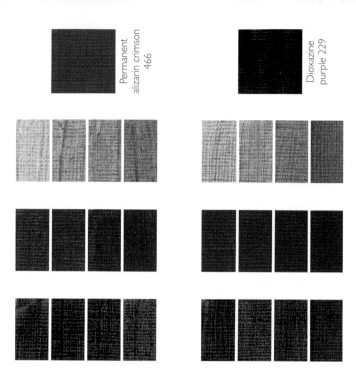

Permanent alizarin crimson 466

Dioxazine purple 229

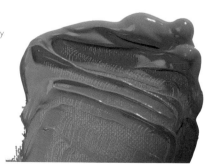

The luscious, buttery consistency of acrylic paint can be further enhanced by using mediums to improve the paint flow, as shown here.

Red iron oxide
560

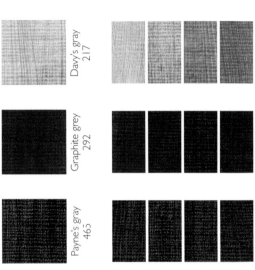

Davy's gray
217

Graphite grey
292

Payne's gray
465

ACRYLIC MEDIUMS THAT ALTER PAINT FINISH **TIP**

Gloss and matt mediums are available that increase the flow of acrylic paint and give it either a matt or gloss finish. A matt medium is particularly good if you work in layers, as it increases the transparency of the paint and allows you to see the underlayers of paint shining through. Acrylic matt or gloss gel mediums thicken the consistency of the paint and help to retain the brushmarks more effectively.

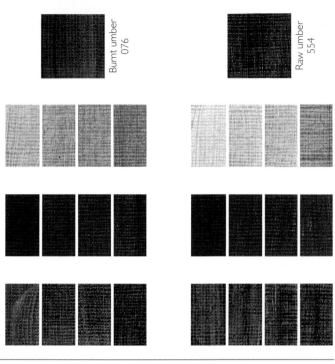

Burnt umber
076

Raw umber
554

Mixing a matt or gloss gel medium will help to stiffen the consistency of acrylic, allowing you to create wonderful impasto effects with every brushmark or palette-knife mark intact in the surface of the painting.

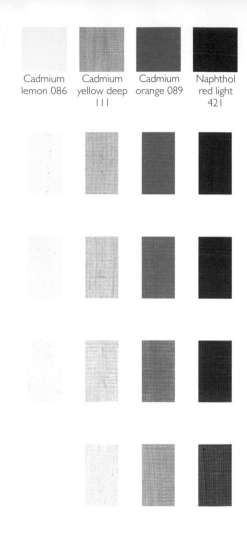

Acrylic
mixed with titanium white

Cadmium lemon 086

Cadmium yellow deep 111

Cadmium orange 089

Naphthol red light 421

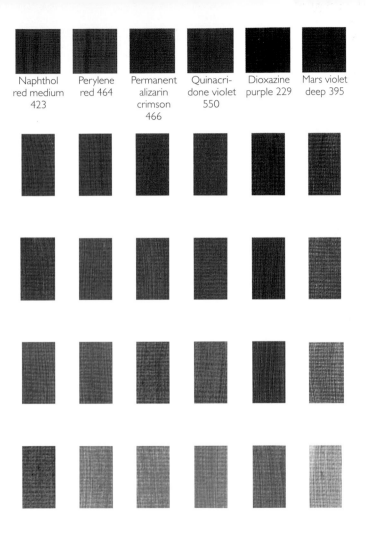

Naphthol
red medium
423

Perylene
red 464

Permanent
alizarin
crimson
466

Quinacri-
done violet
550

Dioxazine
purple 229

Mars violet
deep 395

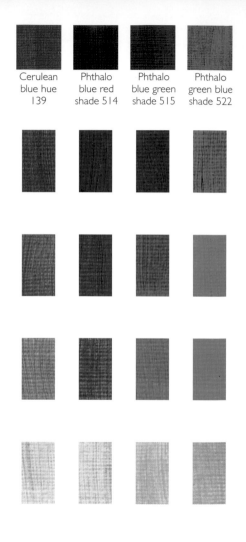

Acrylic
mixed with titanium white

Cerulean
blue hue
139

Phthalo
blue red
shade 514

Phthalo
blue green
shade 515

Phthalo
green blue
shade 522

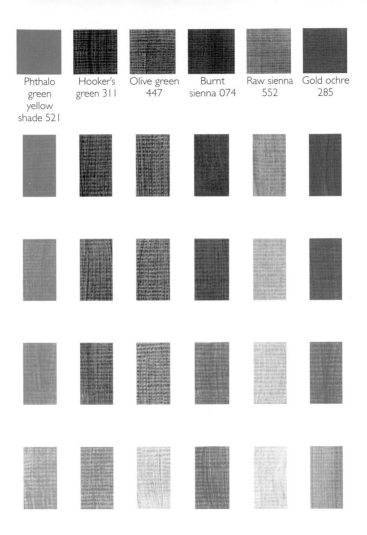

Phthalo green yellow shade 521	Hooker's green 311	Olive green 447	Burnt sienna 074	Raw sienna 552	Gold ochre 285

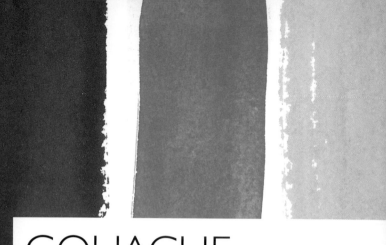

GOUACHE

Gouache paints are opaque watercolours that dry to a matt finish; they are primarily used by designers and illustrators, who use them to create large, flat planes of solid colour, for example for use in poster artwork. However, gouache is also very popular with fine artists. Gouache paints are very versatile and can be used by themselves as an opaque

watercolour, and can also be used in conjunction with traditional watercolour paints to obtain a broader range of opacity and transparency.

Gouache paint is suitable for use on traditional watercolour papers, using a variety of techniques, and is very good for producing flat washes. When gouache is applied to illustration board or hot-pressed (HP) paper, it produces a lovely flat finish.

Gouache

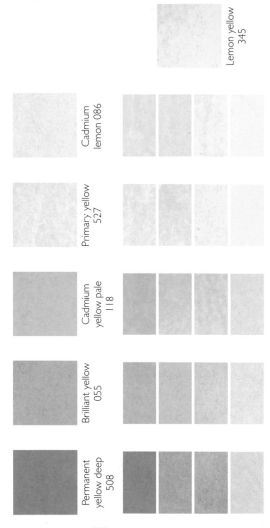

Lemon yellow
345

Cadmium
lemon 086

Primary yellow
527

Cadmium
yellow pale
118

Brilliant yellow
055

Permanent
yellow deep
508

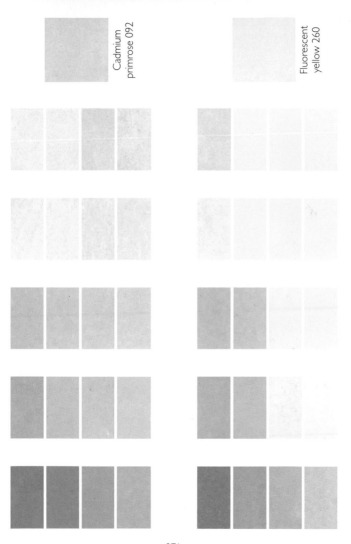

Cadmium
primrose 092

Fluorescent
yellow 260

Gouache

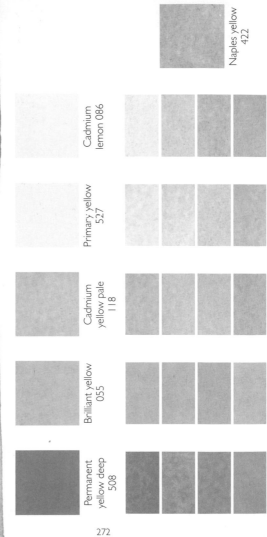

Naples yellow
422

Cadmium
lemon 086

Primary yellow
527

Cadmium
yellow pale
118

Brilliant yellow
055

Permanent
yellow deep
508

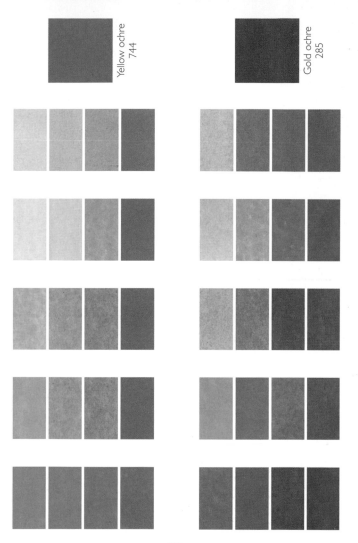

Yellow ochre
744

Gold ochre
285

Gouache

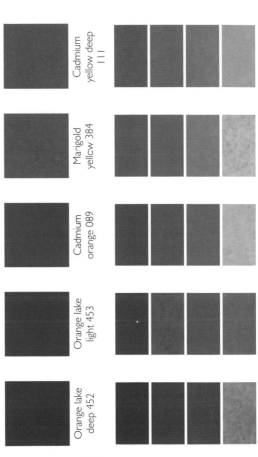

Cadmium lemon 086

Cadmium yellow deep 111

Marigold yellow 384

Cadmium orange 089

Orange lake light 453

Orange lake deep 452

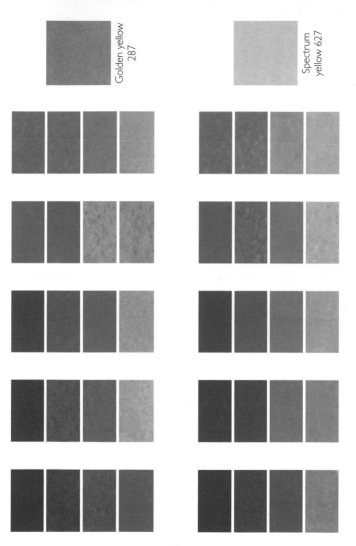

Golden yellow
287

Spectrum
yellow 627

Gouache

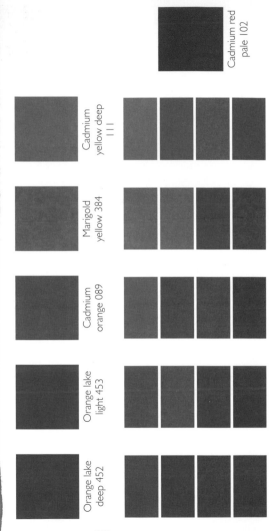

Cadmium red pale 102

Cadmium yellow deep 111

Marigold yellow 384

Cadmium orange 089

Orange lake light 453

Orange lake deep 452

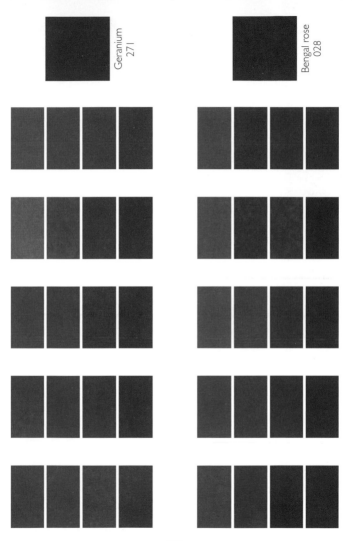

Geranium
271

Bengal rose
028

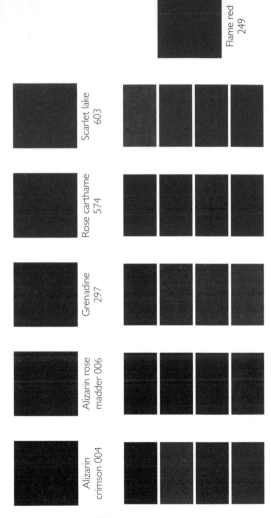

Gouache

Flame red
249

Scarlet lake
603

Rose carthame
574

Grenadine
297

Alizarin rose
madder 006

Alizarin
crimson 004

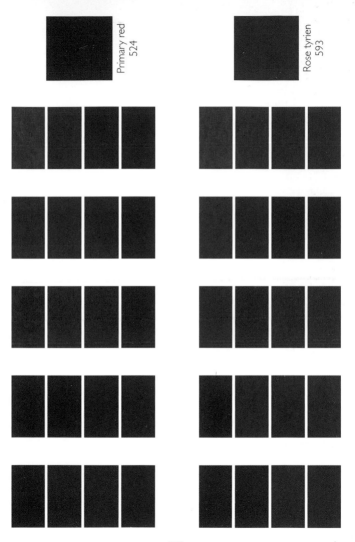

Primary red
524

Rose tyrien
593

Gouache

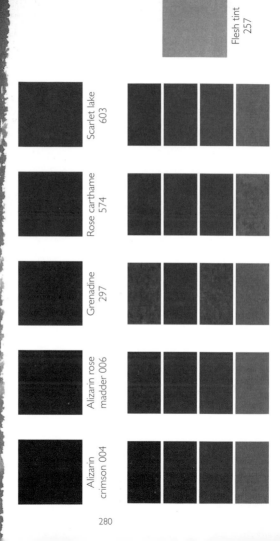

Flesh tint
257

Scarlet lake
603

Rose carthame
574

Grenadine
297

Alizarin rose
madder 006

Alizarin
crimson 004

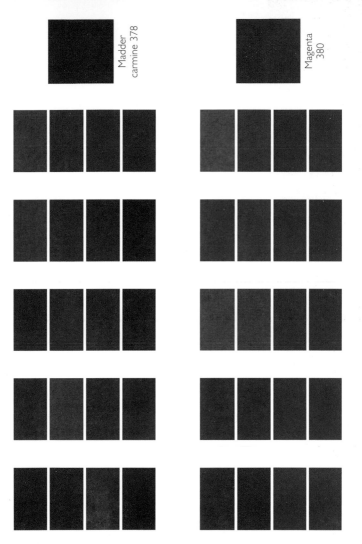

Madder
carmine 378

Magenta
380

Gouache

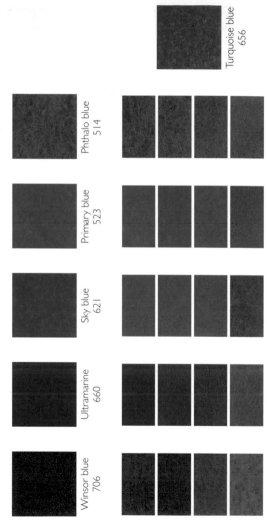

Turquoise blue
656

Phthalo blue
514

Primary blue
523

Sky blue
621

Ultramarine
660

Winsor blue
706

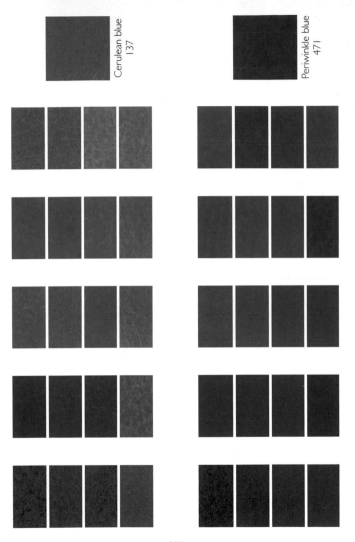

Cerulean blue
137

Periwinkle blue
471

283

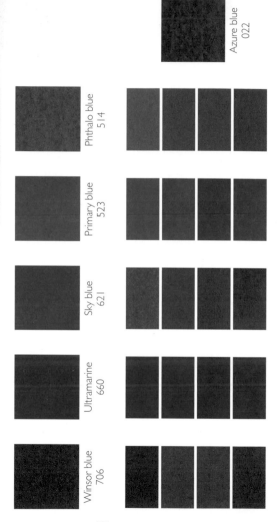

Azure blue
022

Phthalo blue
514

Primary blue
523

Sky blue
621

Ultramarine
660

Winsor blue
706

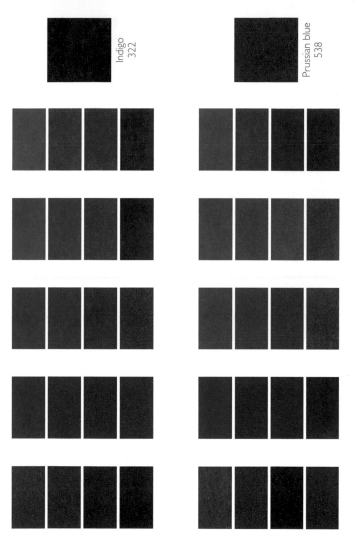

Indigo
322

Prussian blue
538

285

Gouache

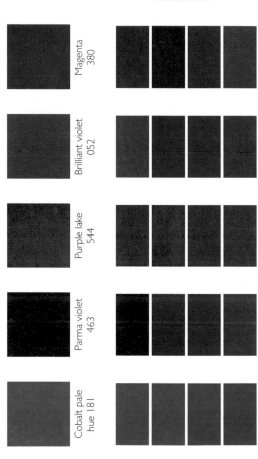

Cobalt blue
178

Magenta
380

Brilliant violet
052

Purple lake
544

Parma violet
463

Cobalt pale
hue 181

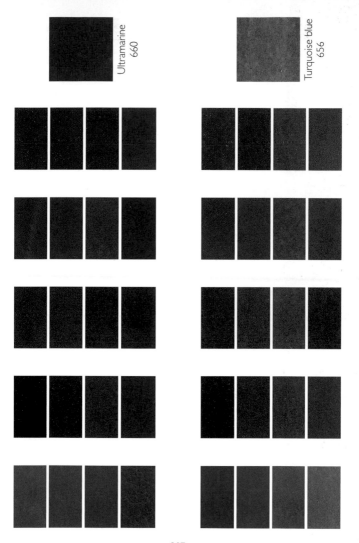

Ultramarine
660

Turquoise blue
656

Gouache

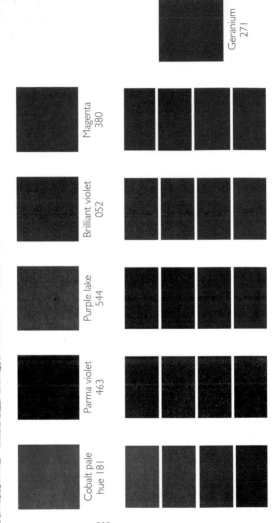

Geranium
271

Magenta
380

Brilliant violet
052

Purple lake
544

Parma violet
463

Cobalt pale
hue 181

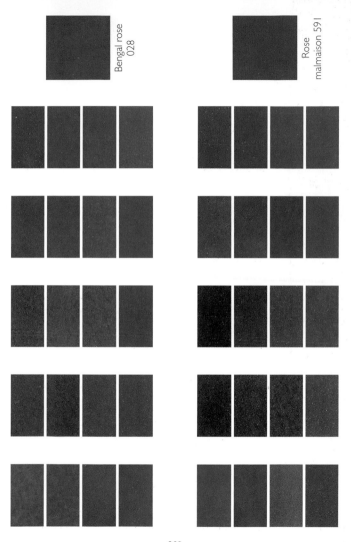

Bengal rose
028

Rose
malmaison 591

Gouache

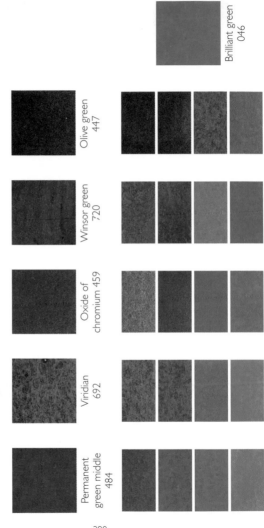

Brilliant green
046

Olive green
447

Winsor green
720

Oxide of
chromium 459

Viridian
692

Permanent
green middle
484

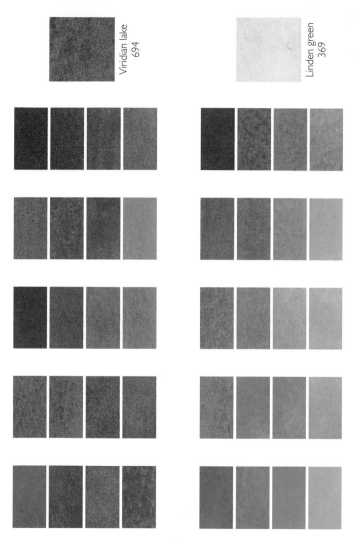

Viridian lake
694

Linden green
369

Gouache

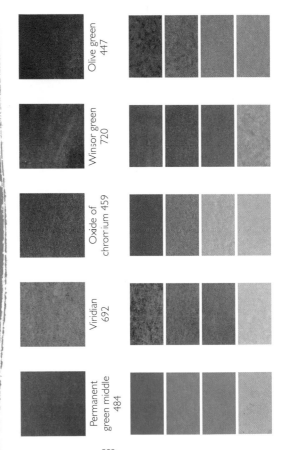

Brilliant yellow
055

Olive green
447

Winsor green
720

Oxide of
chromium 459

Viridian
692

Permanent
green middle
484

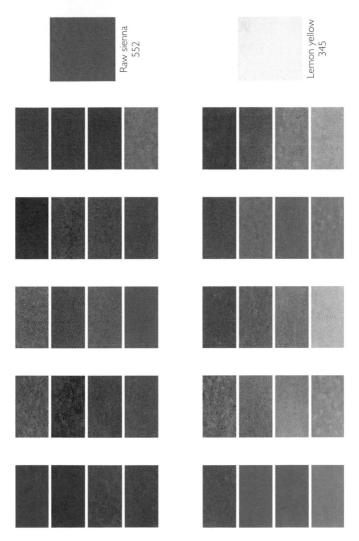

Raw sienna
552

Lemon yellow
345

Gouache

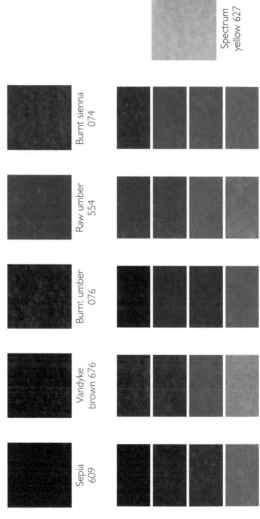

Spectrum
yellow 627

Burnt sienna
074

Raw umber
554

Burnt umber
076

Vandyke
brown 676

Sepia
609

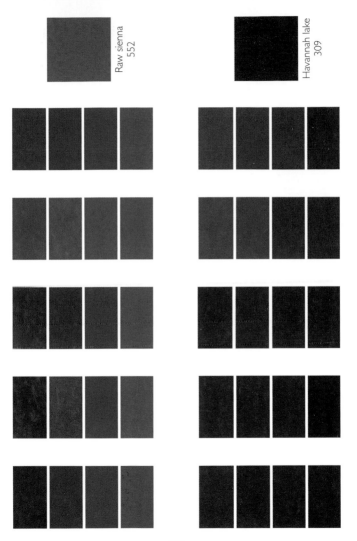

Raw sienna
552

Havannah lake
309

Gouache

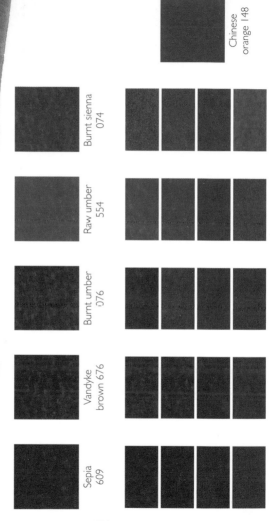

Chinese orange 148

Burnt sienna 074

Raw umber 554

Burnt umber 076

Vandyke brown 676

Sepia 609

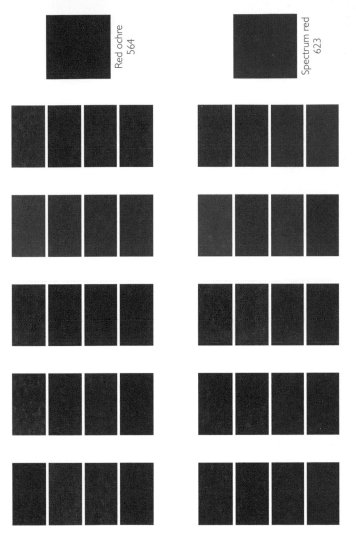

Red ochre
564

Spectrum red
623

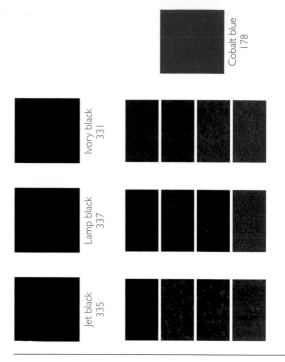

Cobalt blue 178

Ivory black 331

Lamp black 337

Jet black 335

USING GOUACHE **TIP**

Gouache can be used in the same way as watercolour
to produce similar effects, such as wet-in-wet and wet on
dry. Because it is much more opaque, however, you can
also apply it to make a contrast with the diluted paint. The
example opposite shows both qualities.

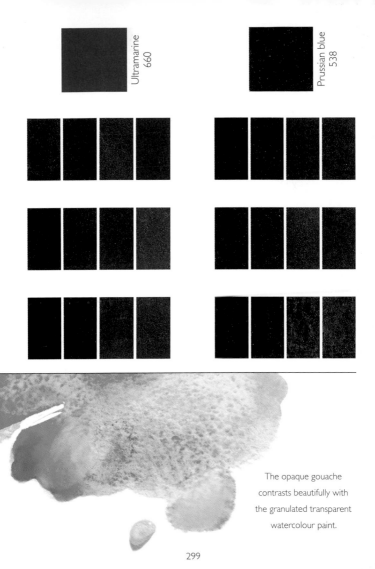

Ultramarine
660

Prussian blue
538

The opaque gouache
contrasts beautifully with
the granulated transparent
watercolour paint.

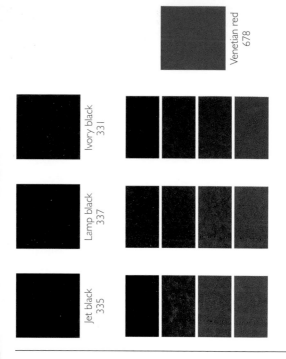

Gouache

Venetian red
678

Ivory black
331

Lamp black
337

Jet black
335

COLOUR MIGRATION **TIP**

Some gouache colours, including the pinks and violets, can
bleed, or migrate, through lighter colours that are painted
over them. Experimenting with these colours can produce
some stunning effects, as seen in the example opposite.

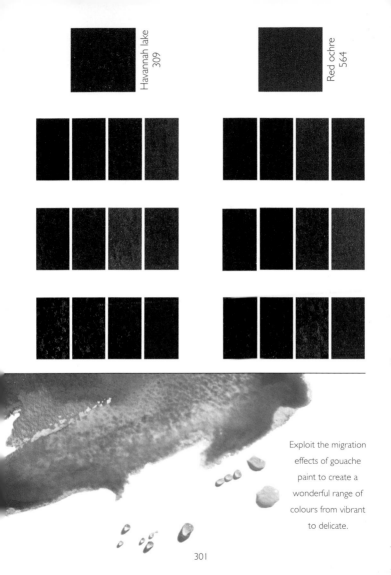

Havannah lake
309

Red ochre
564

Exploit the migration effects of gouache paint to create a wonderful range of colours from vibrant to delicate.

301

Gouache

mixed with permanent white

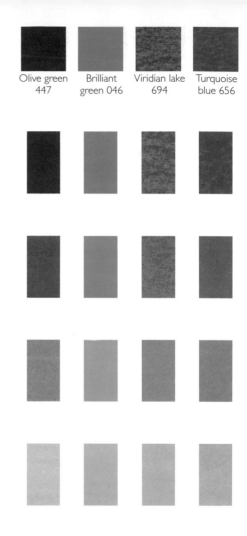

Olive green
447

Brilliant
green 046

Viridian lake
694

Turquoise
blue 656

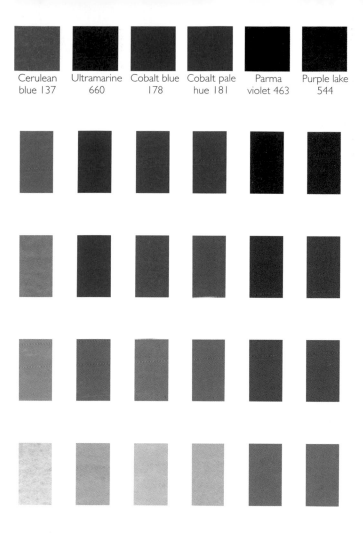

| Cerulean blue 137 | Ultramarine 660 | Cobalt blue 178 | Cobalt pale hue 181 | Parma violet 463 | Purple lake 544 |

Gouache

mixed with permanent white

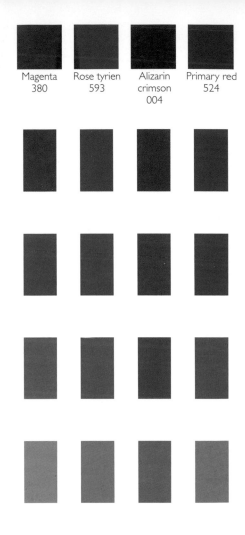

| Magenta 380 | Rose tyrien 593 | Alizarin crimson 004 | Primary red 524 |

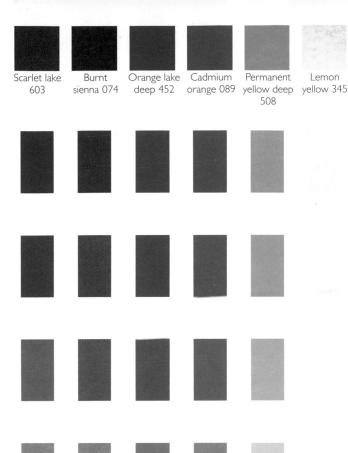

| Scarlet lake 603 | Burnt sienna 074 | Orange lake deep 452 | Cadmium orange 089 | Permanent yellow deep 508 | Lemon yellow 345 |

INK

Drawing inks are made from soluble dyes suspended in shellac solution. These inks can be used directly from the bottle with a dipping pen or a brush. They can also be watered down with distilled water and used much like traditional watercolours. The inks can be mixed together to modify the colours, but, because of their content, they do not mix well with other mediums.

All of the drawing inks that have been used in this book are water-resistant, with the exception of Liquid Indian ink, which is made from traditional Chinese drawing sticks. Because drawing inks contain dyes that aren't lightfast, special care needs to be taken when displaying any work that incorporates inks in order to prevent the colours from fading when they are exposed to light.

Drawing inks can be used with traditional watercolour paper.

Ink

Canary yellow
123

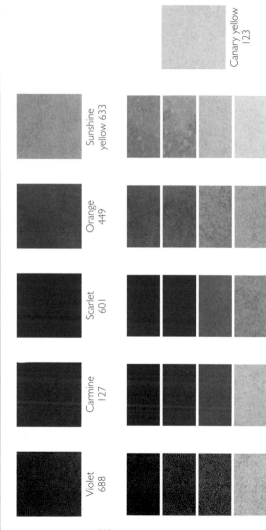

Sunshine yellow 633

Orange 449

Scarlet 601

Carmine 127

Violet 688

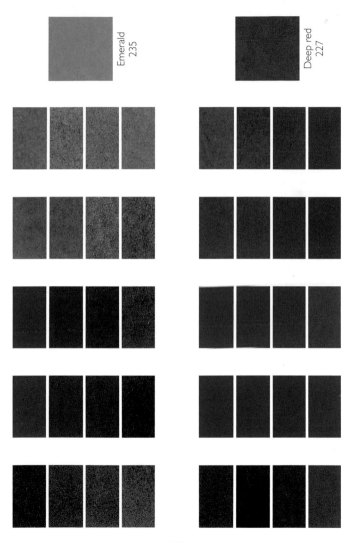

Emerald 235

Deep red 227

Ink

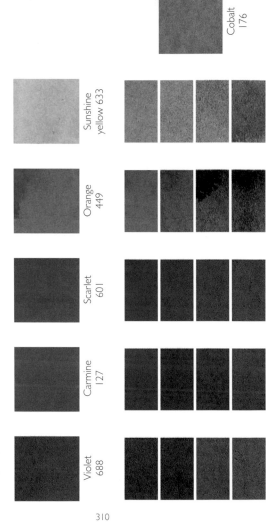

Cobalt
176

Sunshine
yellow 633

Orange
449

Scarlet
601

Carmine
127

Violet
688

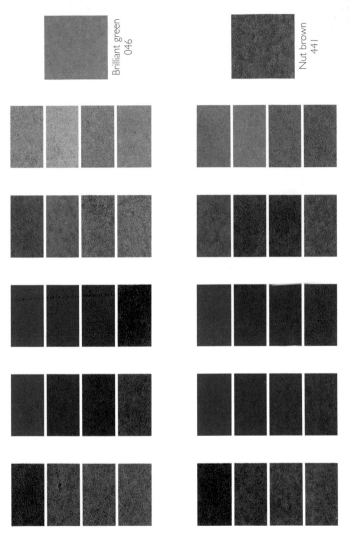

Brilliant green
046

Nut brown
441

Ink

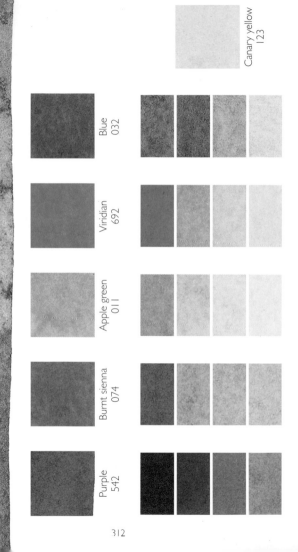

Canary yellow
123

Blue
032

Viridian
692

Apple green
011

Burnt sienna
074

Purple
542

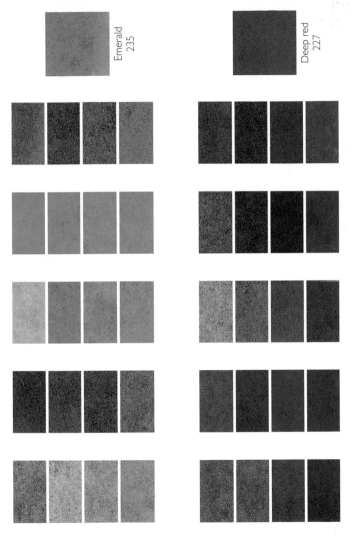

Emerald
235

Deep red
227

Ink

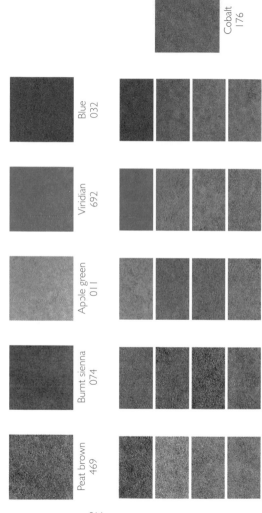

Cobalt
176

Blue
032

Viridian
692

Apple green
011

Burnt sienna
074

Peat brown
469

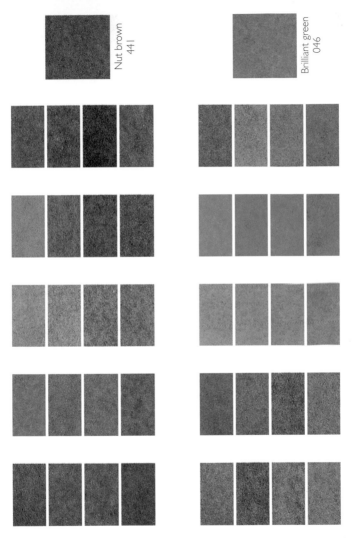

Nut brown
441

Brilliant green
046

diluted with water

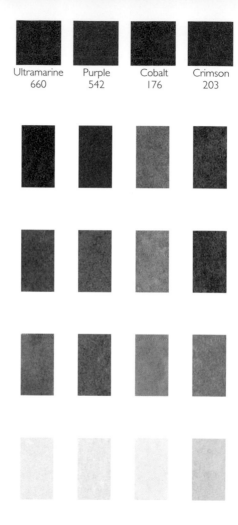

Ultramarine
660

Purple
542

Cobalt
176

Crimson
203

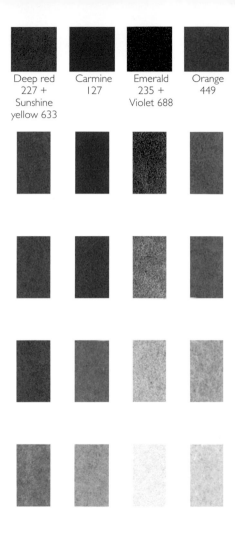

Deep red
227 +
Sunshine
yellow 633

Carmine
127

Emerald
235 +
Violet 688

Orange
449

WINSOR & NEWTON™
The World's Finest Artists' Materials

ABOUT WINSOR & NEWTON™

Winsor & Newton were happy to supply all the artists' materials used in this book. *Winsor & Newton* is the world's leading brand of fine-art materials and has developed an unrivalled reputation for quality, reliability and product information.

For further information please visit www.winsornewton.com
For UK stockist enquiries phone 020 8424 3253
For stockists in the USA phone 800 445 4278

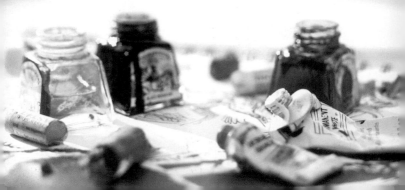

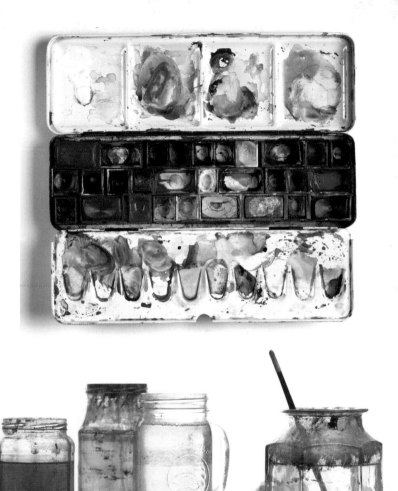

Tear out this card and
cut out the squares
in the centre of each
rectangle to make your
own colour-viewing card.
You can then use the
card to view each colour
swatch in isolation
against a white or a
black background. This
helps you to perceive
each colour individually,
and will also assist when
you are making up your
own colour mixes for
comparison. A lot of the
mixes in the book are
only slightly different
from one another and
when you are faced
with a whole page of
yellows it helps to isolate
each one to decide if
it is the particular mix
you need. A colour will
look brighter and more
luminous against the
black background than
against the white.